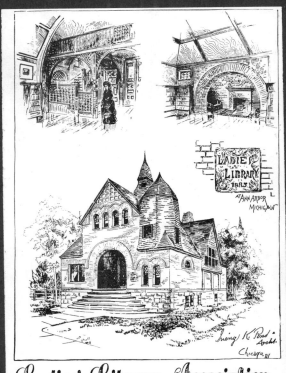

Ladies' Library Association.

HIRSCHFELD'S HARLEM

AL HIRSCHFELD

Introductory Essays by
William Saroyan & Gail Lumet Buckley

Commentary by

Ossie Davis and Ruby Dee

Howard Dodson

Rev. James A. Forbes Jr.

Savion Glover

Whoopi Goldberg

Chester Higgins Jr.

Geoffrey Holder

Lena Horne

Quincy Jones

Eartha Kitt

Carmen de Lavallade

Audra McDonald

Arthur Mitchell

Brian Stokes Mitchell

Albert L. Murray

Charles B. Rangel

Bobby Short

Cicely Tyson

George C. Wolfe

GLENN YOUNG

BOOKS

A GLENN YOUNG BOOK
HIRSCHFELD'S HARLEM

© 2004 Estate of Albert Hirschfeld

Original version published in 1941, as *Harlem as seen by Hirschfeld,* published by the Hyperion Press.

All rights reserved under International and Pan-American Copyright Conventions

Al Hirschfeld is represented by Margo Feiden Galleries Ltd., New York

Cataloging-in-Publication Data

Hirschfeld, Al.
 Hirschfeld's Harlem / Al Hirschfeld ; introductory essays by William Saroyan & Gail Lumet
Buckley. — 1st ed. — New York, NY : Glenn Young Books, 2004.
 p. ; cm.
 Expanded edition of: Harlem as seen by Hirschfeld, published by Hyperion Press
in 1941.
 ISBN: 1-55783-517-9
 1. African Americans in art. 2. Harlem (New York, N.Y.)—In art. 3. Harlem (New
York, N.Y.)—Caricatures and cartoons. 4. Hirschfeld, Al. I. Title.

NC1429.H57 H57 2004
741.5/973—dc22 0312

FIRST EDITION

10 9 8 7 6 5 4 3 2 1

Associate Publisher: Jacqueline Miller Rice
Curator: Louise Kerz Hirschfeld
Production Design: Graffolio
Associate Editor: Greg Collins
Publicity Director: Kay Radtke
Printing: Westcom Graphics / R. R. Donnelley
Image Refinement: Kelly Hanson and Sue Knopf
Research: Robert Ward

The publisher gratefully acknowledges the extraordinary assistance of Louise Kerz Hirschfeld, Tony Walton,
Sue Knopf, Margo Feiden, Robert Lantz, the staff of The Margo Feiden Galleries, Dennis Aspland, Helen Kim,
Robert Setrakian, Gen LeRoy, Victor Seitles and Michael White

All inquiries concerning rights should be addressed to Al Hirschfeld's agent:
The Lantz Office, 200 West 57th Street, New York, NY 10019
Printed in Mexico

Al Hirschfeld's Greatest Lines courtesy of the William Saroyan Foundation
Story in Harlem Slang used with the permission of the Zora Neale Hurston Trust
Brave New Black World, © 2004 by Gail Lumet Buckley
Hirschfeld's Gallery Commentary © 2004 by Estate of Al Hirschfeld and Glenn Young

Back jacket photo © 2004 by Greg Preston

GLENN YOUNG BOOKS
are distributed to the trade by:
HAL LEONARD/APPLAUSE BOOKS
1-800-637-2852 Fax 414-774-3259

www.applausebooks.com

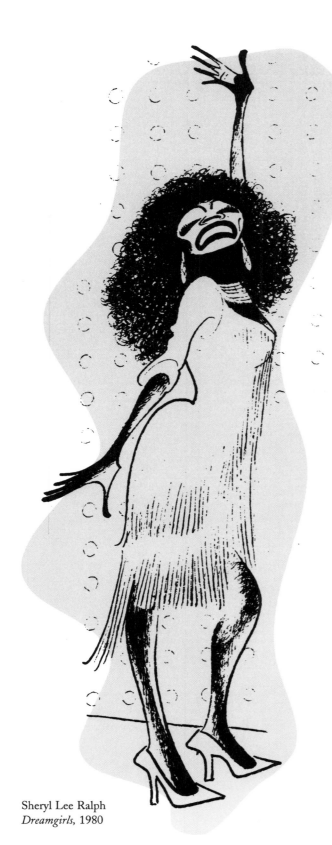

Sheryl Lee Ralph
Dreamgirls, 1980

Drawing on Harlem

I have lived almost my whole life on the outskirts of Harlem. When my mother moved our family to New York City in the middle teens of the previous century, we settled in Washington Heights, the neighborhood just above Harlem. A few years later we moved near the Polo Grounds, which is even closer to Harlem, if not *in* it. When I was of high school age, I began attending the Vocational School for Boys on 138th Street and Lenox Avenue, which I'm almost certain is *in* Harlem. Harlem was as familiar and as accessible to me as the blocks around your house are to you, or the fields around your homestead, or the ice floes around your igloo. When at long last I finally made enough money to buy my own house I bought one on the Upper Upper East Side of Manhattan—just below Harlem.

One of the biggest shocks of my life came only a few years after the end of Prohibition in the mid Thirties. I was just walking down a Harlem street like I always did when a cruising patrol car pulled up next to me. Scared the heck out of me. The cop looked at me like maybe I was crazy. What the hell was I doing walking there anyway. What did he mean, I asked him. Didn't I know, he says, it's not *safe* to walk around Harlem? That incident had a very disquieting effect on me and in some way prompted the work you see before you now. I had been so continuously enchanted with the Harlem I had grown up near and visited my whole life that I was unprepared to see, I resisted, the new Harlem realities that had crept upon her unguarded flanks. And what I began to see post-enchantment was something more akin to love and awe for the Harlemites who carried on.

Harlem people just kept on rising above whatever met them at eye level; regardless of the rugged terrain or the economic weather, Harlem residents had their own means of levitation. They perfected an art form beyond the Arts, beyond the stage, beyond the Cotton Club. Very real people meeting reality head on and then stubbornly transcending it. Some commentators have made much of the fact that these

Ruth Brown
Black and Blue, 1989

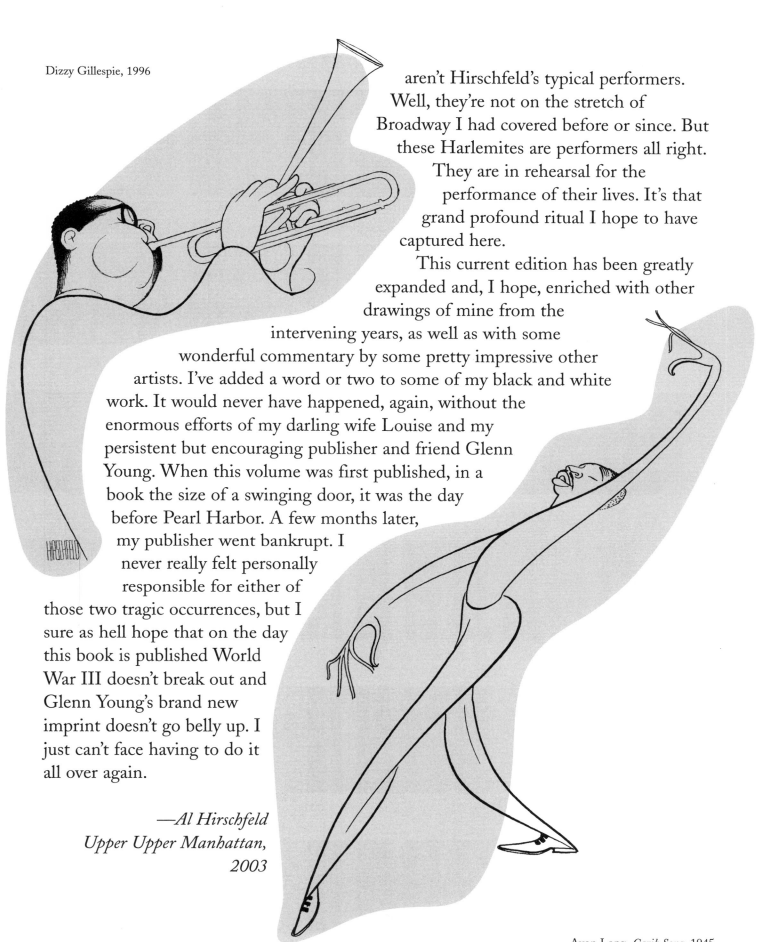

Dizzy Gillespie, 1996

aren't Hirschfeld's typical performers. Well, they're not on the stretch of Broadway I had covered before or since. But these Harlemites are performers all right. They are in rehearsal for the performance of their lives. It's that grand profound ritual I hope to have captured here.

This current edition has been greatly expanded and, I hope, enriched with other drawings of mine from the intervening years, as well as with some wonderful commentary by some pretty impressive other artists. I've added a word or two to some of my black and white work. It would never have happened, again, without the enormous efforts of my darling wife Louise and my persistent but encouraging publisher and friend Glenn Young. When this volume was first published, in a book the size of a swinging door, it was the day before Pearl Harbor. A few months later, my publisher went bankrupt. I never really felt personally responsible for either of those two tragic occurrences, but I sure as hell hope that on the day this book is published World War III doesn't break out and Glenn Young's brand new imprint doesn't go belly up. I just can't face having to do it all over again.

—*Al Hirschfeld*
Upper Upper Manhattan,
2003

Avon Long, *Carib Song*, 1945

5

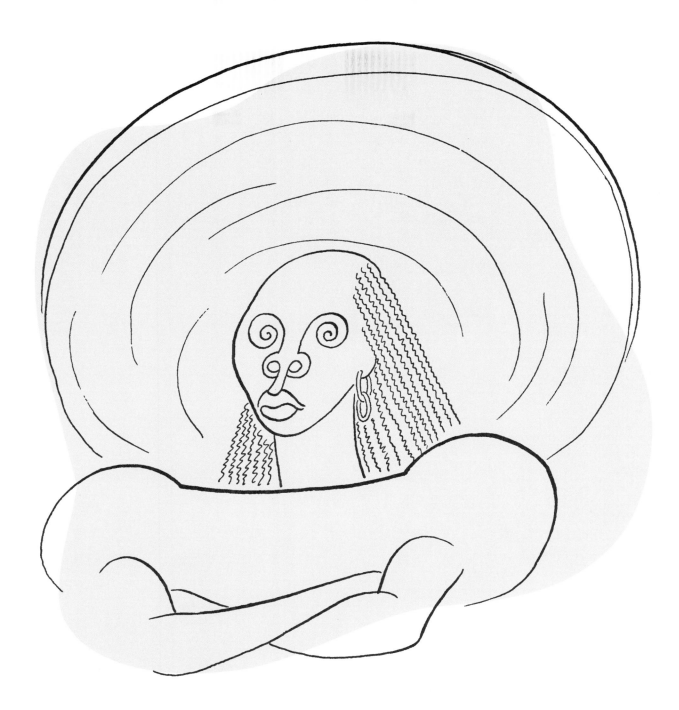

Al Hirschfeld's Greatest Lines

WILLIAM SAROYAN

Some of the greatest acting I have ever seen has been the acting of Al Hirschfeld telling a story about himself in Persia or about a friend of his in an automobile. Telling a story yourself, as you go along, is art. It is probably the earliest art, and I believe you will find after years of careful listening and watching that it is an art practiced only by the most cultured or the most innocent.

Hirschfeld is both.

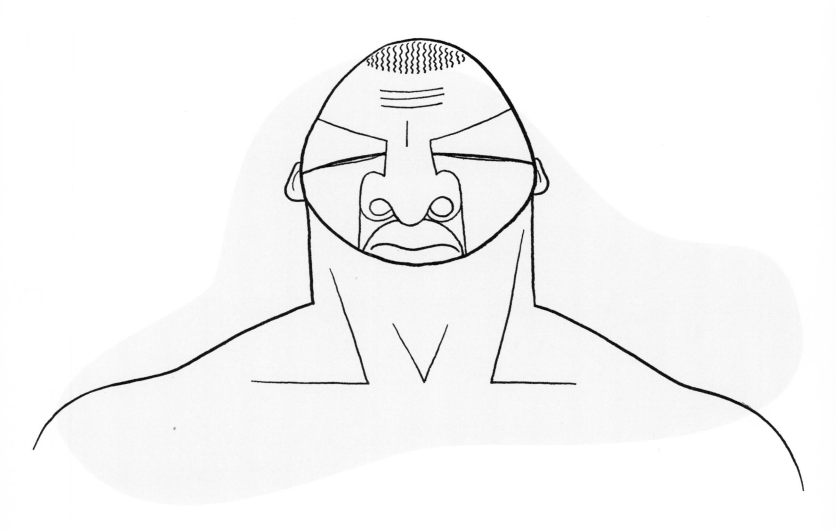

His culture is unobtrusive but all over the place, and his innocence holds its hand.

I am fond of all people, but most fond of those who get me laughing, because if I don't laugh I feel bad. There are kinds of laughter and while any kind is better than none, the kind I prefer is the kind that has depth and means everybody is immortal. This is the kind of laughter Hirschfeld gets going in me.

I go up to his place on 57th Street every Saturday night when I'm in New York and this fellow with the black beard who draws pictures for the papers opens the door. Before him stands a wretch whose spirit has been hushed by the fever and shouting of a wonderful city, populated by a magnificent race of insane human beings.

Hi-ya, Al, says the well-dressed young wretch.

Come on in, says the fellow with the beard.

So I go in and walk around for two or three minutes while Hirschfeld tells me what happened to him on the way to his apartment, the way the old vaudeville boys used to tell us about what happened to them on the way to the theatre. Well, the first thing I know I'm catching on, the next thing I know I'm smiling, and then — boom — the old artist is swinging out and I'm on the floor with laughter.

Hah hah hah, I keep saying.

Comedy is abundance of innocent energy, and laughter is gratefulness for the

existence of that energy. Comedy's style is made by the culture and temper of the man —
I could say comedian but I won't. If there is a great man who is not a comedian, he is not
a great man, he is a bore. Anybody can be great and funny both, and I like to think
everybody's immortal, and funny. Some don't know they're funny, consequently they can't
suspect that they are immortal, but somehow or other they *are* funny. The ones who
know they're immortal are funnier, and artists. An artist is a guy who goes about his
business with a wink. He does his work with the joy of a drunkard kicking an army
downstairs, and even if it is only himself bouncing off the floor, his ancient heart knows
a powerful enemy has been routed and sent flying to the woods.

Every time I've had Sunday supper at Al's house he's dished out frankfurters of
some kind. The last time this happened he said, I suppose you think frankfurters is the
only thing I eat. Now if I had been a
wit I would have said something so
wonderful people for miles around
would have stopped dying
and looked around
for rocks to

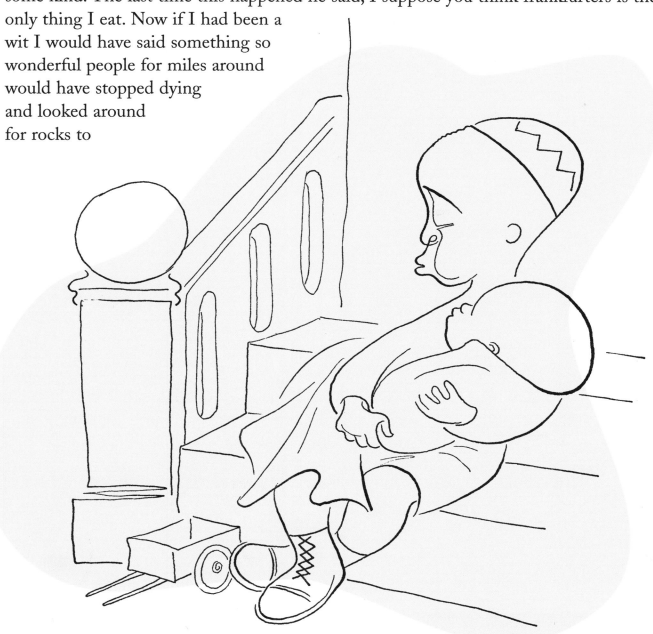

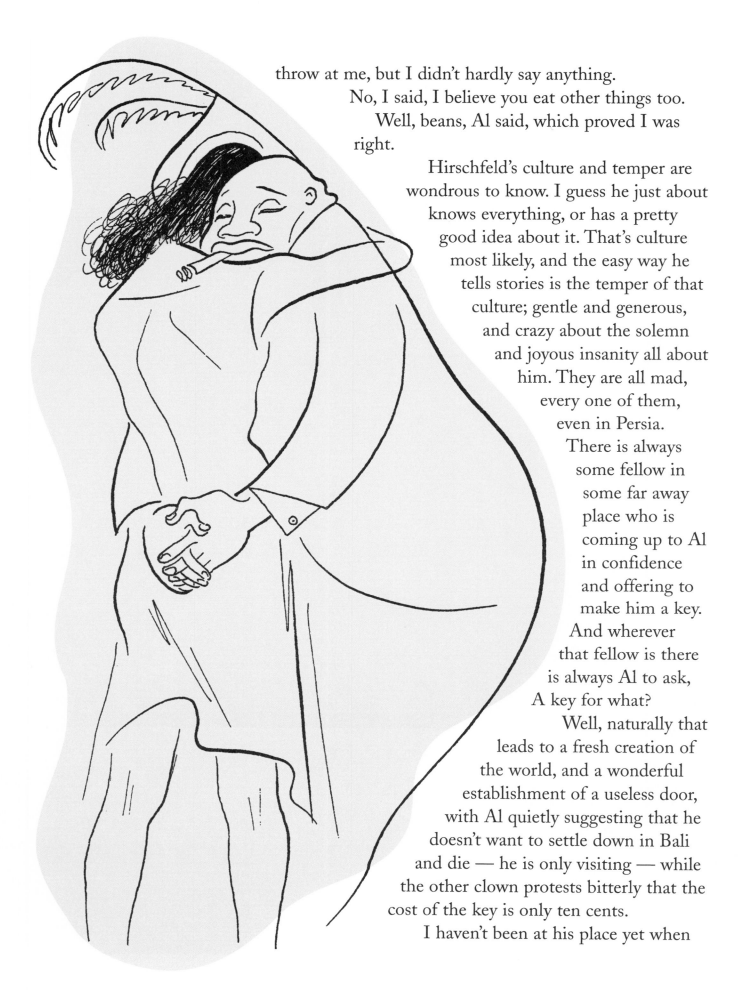

throw at me, but I didn't hardly say anything.

No, I said, I believe you eat other things too.

Well, beans, Al said, which proved I was right.

Hirschfeld's culture and temper are wondrous to know. I guess he just about knows everything, or has a pretty good idea about it. That's culture most likely, and the easy way he tells stories is the temper of that culture; gentle and generous, and crazy about the solemn and joyous insanity all about him. They are all mad, every one of them, even in Persia.

There is always some fellow in some far away place who is coming up to Al in confidence and offering to make him a key. And wherever that fellow is there is always Al to ask, A key for what?

Well, naturally that leads to a fresh creation of the world, and a wonderful establishment of a useless door, with Al quietly suggesting that he doesn't want to settle down in Bali and die — he is only visiting — while the other clown protests bitterly that the cost of the key is only ten cents.

I haven't been at his place yet when

10

he didn't have somebody try to trick him into some immortal variety of foolishness, pretending to be his friend or a man with secrets about agriculture, or ropes. But he has always escaped and returned to New York.

All this is dancing of a sort, I guess, as this book is a book of pictures of the dances of Harlem.

Dancing is a thing I could wax eloquent about if I got in the right frame of mind for it and worked hard, but I get tired when I work hard. Dancing is the language without the words, because the words don't say it. The hand says it, the leg says it, the head and neck say it, the thighs and all the rest of it say it, and nobody need say of it, What's it mean? Nobody but the great international bone-head who says it of everything but his head, which is the only thing he should say it of. Dancing is the heart or spirit brought out and placed among the moving limbs of the old folks who are lucky enough to be young, along about now. Kid stuff, the same as death. The painted boy with the sword and the fancy showing-off. The girl with the crown and bracelets, and the slow and thoughtful contest with time going through her fingers and along her arms. All that stuff. I could wax eloquent, but you do it instead. You know a thing or two, too, I guess.

Every time I've walked in Harlem I've heard them laughing, and even though I've never known what it was about, I've laughed too, because they haven't cared either. They've only been out in the streets and remembered that they'd been out before, and man oh man they'd be out in Harlem again and again. I've talked to them too, and one of them who

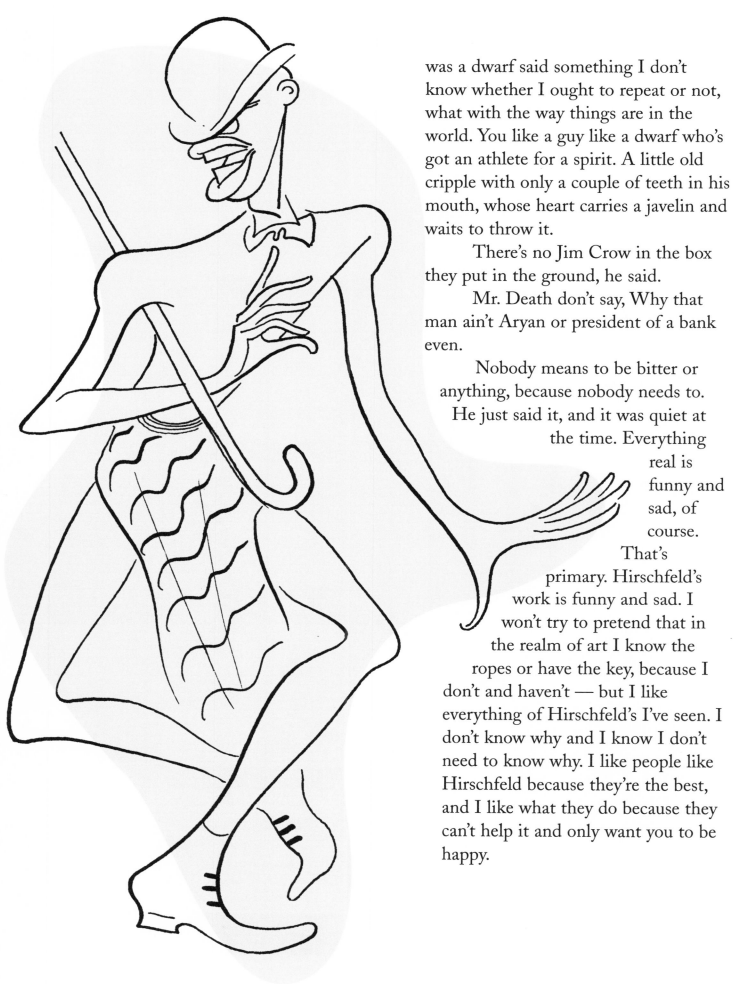

was a dwarf said something I don't know whether I ought to repeat or not, what with the way things are in the world. You like a guy like a dwarf who's got an athlete for a spirit. A little old cripple with only a couple of teeth in his mouth, whose heart carries a javelin and waits to throw it.

There's no Jim Crow in the box they put in the ground, he said.

Mr. Death don't say, Why that man ain't Aryan or president of a bank even.

Nobody means to be bitter or anything, because nobody needs to. He just said it, and it was quiet at the time. Everything real is funny and sad, of course. That's primary. Hirschfeld's work is funny and sad. I won't try to pretend that in the realm of art I know the ropes or have the key, because I don't and haven't — but I like everything of Hirschfeld's I've seen. I don't know why and I know I don't need to know why. I like people like Hirschfeld because they're the best, and I like what they do because they can't help it and only want you to be happy.

Brave New Black World:
A Century of Harlem Renaissance

GAIL LUMET BUCKLEY

"Feeling . . . fine and mellow," the black artist
Beauford Delaney, who lived in Greenwich
Village, wrote his friend Al Hirschfeld,
sometime in 1940. "If at any time you should like to go
to Harlem I would be most happy to take you along
the street where we can find real local color and also
enjoy it." Delaney was twenty-nine and Al was two
years younger when they first struck up a conversation
in 1930 at the Whitney Studio Galleries (forerunner of
the Whitney Museum) on Eighth Street in Greenwich
Village. Delaney worked as doorman-attendant-
caretaker, in exchange for studio-living space in the
basement. The conversation at the door became a life-
long friendship—with Al becoming Delaney's collector,
patron, and benefactor. I like to think that *Hirschfeld's Harlem*
might be the result of a nostalgic return to Harlem by two old
friends who had known the Renaissance.

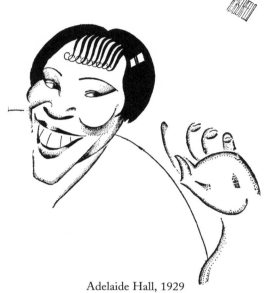

Adelaide Hall, 1929

Harlem . . . Harlem	*Ask Rudolph Fisher*
Black, black Harlem	*Don't damn your body' itch*
Souls of Black Folk	*Ask Countee Cullen*
Ask Du Bois	*Does this jazz band sob?*
Little grey restless feet	*Ask Langston Hughes*
Ask Claude McKay	*Nigger Heaven*
City of Refuge	*Ask Carl Van Vechten.*

This poem was written by my great-uncle, Dr. Frank Horne, one of the "second
echelon" of Harlem Renaissance poets. His collected poems of college life, *Letters Found*

near a Suicide, won the NAACP's *Crisis* magazine poetry prize in 1925. As an eye specialist, educator, government official, and member of FDR's later so-called "Black Cabinet," he was a part-time poet. But as a younger Renaissance figure, he was a friend of all the writers mentioned in "Harlem"—which was published in the June 1928 issue of *The Crisis.* Writing in Arna Bontemp's 1972 anthology, *The Harlem Renaissance Remembered,* Ronald Primeau calls the poem "an all-encompassing catalog of the sights and sounds of Harlem" and "a short résumé of the entire period." The same thing could be said of *Hirschfeld's Harlem*—only Al's drawings encompass two distinct periods. They are "an all-encompassing catalog of the sights and sounds of Harlem" at the end of its golden age, filtered through a Renaissance memory.

Miller & Lyles, *Rang Tang,* 1927

The Renaissance memory actually reflects two Harlems: Harlem by day, which mostly belonged to blacks, and Harlem by night, which belonged almost as much to whites—who arrived in droves throughout the 1920s and much of the 1930s. Black nightlife and white tourist nightlife rarely coincided; except, perhaps, ironically. There was a time "when white people went to Negro cabarets to see how Negroes acted; now Negroes go to these same cabarets to see how white people act," wrote Rudolph Fisher, in *The Caucasian Storms Harlem.* "A visit to Harlem at night—the principal streets never deserted, gay crowds skipping from one place of amusement to another, lines of taxicabs and limousines standing under the sparkling lights of the entrances to the famous nightclubs, the subway kiosks swallowing and disgorging crowds all night long—give the impression that Harlem never sleeps and that the inhabitants thereof jazz through existence," wrote James Weldon Johnson in *Black Manhattan,* published in 1930. This, of course, is the Harlem of tourists, not the Harlem of natives trying to make ends meet. Yet, Johnson wrote, "[G]aiety is peculiarly characteristic of Harlem"—and an "average group of Negroes can in dancing to a good jazz band achieve a delightful state of intoxication

that for others would require nothing short of a certain per capita imbibition of synthetic gin."

That Prohibition and the Harlem Renaissance coincided was sheer luck. Prohibition, Puritanism, and the KKK gripped the hinterlands—but in Harlem spirits flowed and even interracial friendships were posssible. Everything that was illegal in the rest of America seemed to be legal in Harlem—which had the dubious distinction of being protected by gangsters as well as City Hall. Freckle-faced mobster Owney Madden owned the Cotton Club as well as most of Harlem's illegal activities. And Mayor Jimmy Walker, New York's "nighttime Mayor" and charming rogue, put Harlem on the official VIP visitors list. "The atmosphere of Harlem was like ancient Rome," remembered white filmmaker Samuel Fuller in *New York in the 1930s*. "It was a neighborhood that lived by night and was reputed to have over one hundred nightclubs . . . the nocturnal playground for people who began the evening with a Broadway show and then went on to swing all night."

Swinging all night included some of the greatest entertainment per square mile in America. In 1932, the black cartoonist E. Simms Campbell, whose work regularly appeared in *Esquire,* drew his famous "Night-Club Map of Harlem"—featuring the sights and sounds of Lenox and Seventh Avenues, from 110th to 142nd Street. "The stars indicate the places that open all night," wrote Campbell. The big tourist clubs with all-black entertainment were, mostly, for white customers only. At 131st and Seventh, Connie's Inn was for whites only. Louis Armstrong, Fletcher Henderson, and Fats Waller all played there. Next door is the integrated Lafayette Theatre, with its Tree of Hope, good luck symbol for actors and musicians. Campbell's map features Bill "Bojangles" Robinson at a midnight revue. At 132nd and Lenox, the integrated Savoy Ballroom has Earl "Snakehips" Tucker—and couples doing the Lindy Hop. Blacks and whites mingled as equals, more or less, on 133rd between Lenox and Seventh, known as "Jungle Alley." Tillie's for fried chicken, attracting visitors from uptown and down, and the Log Cabin, "an intimate little spot," were two of Campbell's "Jungle Alley" favorites. The Club Hot-cha, between 134th and 135th on Lenox, was

Stepin Fetchit, *Walk with Music,* Barrymore Theatre, 1940

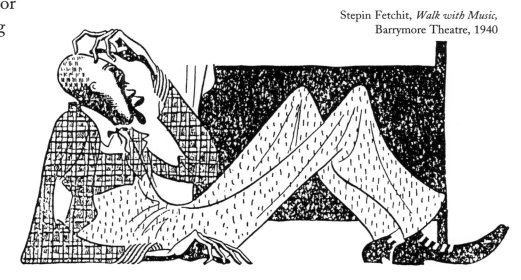

open all night for white customers—but "nothing happens before 2 A.M.," Campbell warns. "You've never heard a piano really played until you hear Garland Wilson," he says of the Theatrical Grill, on 134th between Lenox and Seventh. Small's Paradise, on 135th and Seventh, famous for "café-au-lait girls and dancing waiters," was started by a descendant of black Civil War hero Captain Robert Smalls for mostly white customers. Across the street from Small's, the Yeah Man was also open all night; "Go late," says Campbell. "Gladys Bentley wears a tuxedo and a high hat and tickles the ivories" he says of Gladys' Clam House, open all night on 136th between Seventh and Lenox, whose mainly white clientele, according to Samuel Fuller, "had the reputation of being the most promiscuous of Jungle Alley." Gladys Bentley was famous for wearing male drag and putting risqué lyrics to popular songs. At 142nd and Lenox, the Cotton Club was the queen of Harlem night life. It opened in 1923, famous for

Wesley Hill,
Green Pastures, 1930

the most highly paid performers, the most beautiful chorus girls, and the best shows in Harlem—written by Andy Razaf, James P. Johnson, Dorothy Fields, Jimmy McHugh, Harold Arlen and Duke Ellington. It introduced songs like "When my Sugar Walks Down the Street," "Minnie the Moocher," "Life is Just a Bowl of Cherries," "I've Got the World on a String" and "Stormy Weather"—and featured stars like Ellington, Ethel Waters, Jimmie Lunceford and Cab Calloway. Campbell's Calloway is "hi-de-hoing" as the doorman bows to an ermine-and-pearls and top-hatted white couple in a limousine. Unlike Small's and Connie's Inn, the Cotton Club admitted certain black customers— generally political VIPs or black gangsters—always seated in the back near the kitchen.

Cotton Club boss Owney Madden had given the Harlem numbers concession to blacks. (William "Bub" Hewlett, a black ex-World War officer, was Madden's righthand Harlem numbers man. He was also my grandfather Ted Horne's best Harlem friend. So Ted Horne, brother of Frank, was allowed to sit in the back to see his sixteen-year-old daughter Lena dance in the Cotton Club chorus in 1933, when Calloway was the star.) Next door to the Cotton Club, the Radium Club, open all night, had a "big breakfast

dance every Sunday morning at 4 or 5 A.M." Campbell's map features Harlem natives and white visitors along with local characters like the "Crab Man," and the "Reefer Man," selling "marijuana cigarettes 2 for $25." And everyone seems to be asking about the day's "numbah"; even black and white policemen at the "nice new police station" next to Small's—"open all night." "The only important omission," writes Campbell of his map, "is the location of the various speakeasies, but since there are about 500 of them you won't have much trouble." Al Hirschfeld and Beauford Delaney, who knew Campbell's map very well, would undoubtedly have had no trouble finding the former speakeasies of their younger days.

Al Hirschfeld arrived in New York in 1914, aged eleven, just as Harlem was coming into its own as a black community. Thanks to construction of the IRT subway and apartment speculation on Lenox Avenue, which created more apartments than could be filled, Harlem began to be home to New York blacks around 1900. With the housing market collapse, black realtor and entrepreneur Philip A. Payton, Jr. and his ten-investor Afro-American Realty Company convinced white property owners to open blocks to blacks at premium rents. For the first time in the history of New York, blacks could live in new dwellings. In the 1920s, as in most of its history, Harlem was overcrowded. From 1900 to 1915 waves of immigrants came to America. And waves of black immigrants from Africa, Central and South America, the West Indies, the Caribbean, and the southern United States descended on Harlem. Throughout most of its history, Harlem paid the highest rents and received the least and poorest public services in New York City. Both city officials and landlords knew that blacks had no place else to go. "Harlem inherited its physical framework," said the March 1925 issue of the Urban League's *Survey* magazine, "like the poor relation who inherits a limousine: he can ill afford to keep it going." The story of black New York's wandering trek, or slow migration, from the bottom of Manhattan Island to the top, with stops in between from Greenwich Village to the West 50s San Juan Hill, is a saga worthy of grand opera or a great American novel. There had been other flowerings of

Noble Sissle, 1928

black culture in America: during the Revolutionary era and right after the Civil War, during Reconstruction. But the Harlem Renaissance was the first flowering that was specifically about a *place*. "Harlem is neither slum, ghetto, resort nor colony, though it is in part all of them," wrote Alain Locke, editor of *The New Negro* anthology, in 1925. "It is—or promises to be—a race capital." Between 1919 and 1929, Harlem's magic years, it was, indeed, a race capital.

These magic years were known as the Jazz Age—named for black music. "Jazz reached the height of its vogue at a time when minds were reacting from the horrors and strain of war," wrote black historian and propagandist J. A. Rogers in 1925. Harlem officially dated the beginning of the Jazz Age as February 17, 1919, when the all-black 369th New York National Guard Regiment, "the Harlem Hell Fighters," the most highly decorated and longest-fighting American

Billie Yarbo, *Keep Shufflin'*, 1928

unit in the war, led the World War Victory Parade up Fifth Avenue. It was a day, wrote one of the regiment's white officers, when "New York City knew no color line." The world was jazz-mad by February 1919, thanks, in great part, to the 369th Regimental Band and its leader, a black officer, Lieutenant James Reese Europe, who brought the new American music to every corner of war-torn France during the band's famous 1918 Goodwill Tour. Harlem as a Mecca for entertainment actually began just before the war with James Reese Europe's Clef Club Orchestra, which, in 1912, gave the first jazz concert in Carnegie Hall. Called "the Paderewski of syncopation" by the *New York Sunday Press,* Europe actually had two musical personalities. As James Reese Europe, he dreamed of a National Negro Orchestra. As Jim Europe with his "Society Orchestra," he was a Victor recording star and conductor-arranger for Vernon and Irene Castle, the couple who invented modern ballroom dancing and made America dance-mad.

Black veterans of the First World War came home to one of the most overtly racist eras in American history—under Woodrow Wilson, arguably America's most overtly racist president. The summer of 1919 was known to blacks as "Red Summer": red, for blood. Between June and December, there were race riots in twenty-eight cities; and seventy-eight blacks were lynched —ten of them veterans, some in uniform. But the war had created a "New Negro." He had fought to help change Europe; now he was willing to fight to change America. "If we must die, O let us nobly die . . . /Like men we'll face the murderous, cowardly pack/ Pressed to the wall, dying, but fighting back," wrote Jamaica-born poet Claude McKay during the July 1919 Washington, D.C. race

riot. This new spirit was also noticed by whites. According to a letter to the white *Arkansas Gazette* in January 1920: "We have a new negro; he has come back from the war changed . . . In some cases he has come back with ideas of social and political equality."

The cultural history of blacks in America, thus far, had been about assimilation. Now, however, people as philosophically different as W. E. B. Du Bois and Marcus Garvey were invoking pan-Africanism. If not as literal as Garvey's return to the Motherland, pan-Africanism was about a return to, or appreciation of, all things African, including African heritage. This sense of race pride and race esthetic, the earliest known version of "Black is Beautiful," was called *negritude*. It was about being proud of being black; not proud of being as white as possible. Negritude was celebrated by whites as well as blacks. Picasso is supposed to have changed the faces of the "Demoiselles d'Avignon" into cubist masks after seeing the 1919 exhibit in Paris of African tribal art from former German colonies. Eugene O'Neill wrote two powerful plays with black themes: *The Emperor Jones,* in 1920, and *All God's Chillun,* in 1924. In 1926, one of the chief white "celebrators,"
Carl Van Vechten, wrote a novel, *Nigger Heaven,*
whose title infuriated many blacks, but only added to
the Harlem mystique. "Part of the Manhattan
zeitgeist of this period," wrote Samuel Fuller "was
the desire for a more truthful understanding of black
and white relationships." In the years between the
two world wars, two different sorts of whites went to
Harlem: those who went to have fun, and those who
went to learn or be inspired. Many, of course, did
both.

One of the most important aspects of
negritude, as well as the Renaissance as a whole, was
independence from the old forms. "We younger
Negro artists who create now intend to express our
individual dark-skinned selves without fear or
shame," wrote Langston Hughes in his famous 1926
manifesto. "If white people are pleased we are glad.
If they are not, it doesn't matter. We know we are
beautiful. And ugly, too. The tom-tom cries and the
tom-tom laughs. If colored people are pleased we are
glad. If they are not, their displeasure doesn't matter
either. We build our temples for tomorrow, strong as

Teddy Wilson & Lionel Hampton, 1985

André Watts, 1987

we know how, and we stand on the top of the mountain free from within ourselves."

Frank Horne wrote of Harlem's literary and intellectual Renaissance. The names by now are familiar. But the Harlem Renaissance was also theatrical and artistic. Theatrical entertainment was always a key aspect of Harlem life. Although turn-of-the century black cakewalk musicals, written by Will Marion Cook and the poet Paul Laurence Dunbar, were Broadway hits, in 1910, in the wake of New York race riots, blacks were forbidden to appear on Broadway. The only exception was Bert Williams, the great black star of the *Ziegfeld Follies,* a light-skinned black who sang his hit songs "Nobody" and "Ace in the Hole" in blackface.

But theatrical Harlem came into its own with the Lafayette and Apollo Theaters and the Harlem Opera House, doing dramas as well as musicals. The major Renaissance dramatic names were Charles Gilpin, Rose McClendon, and Paul Robeson. Harlem had its first great theatrical moment in 1913, with the Lafayette Theatre production *Darktown Follies*, which became the toast of New York. Ziegfeld bought the rights to produce "At the Ball," the first act finale, in his own *Follies* downtown. "The whole company formed an endless chain that passed before the footlights and behind the scenes, round and round, singing and executing a movement from a dance called 'ballin' the jack,' one of those Negro dances which periodically come along and sweep the country," wrote James Weldon Johnson. "This finale was one of the greatest hits the *Ziegfeld Follies* ever had."

Blacks were back on Broadway by 1921, with one of the biggest hits and biggest stars. The show was *Shuffle Along,* and the star was Florence Mills. Written by black composers Noble Sissle (ex-member of the 369th Regiment Band) and Eubie Blake, hit songs included "I'm Just Wild About Harry" and "Love Will Find a Way." "Every Thursday and Saturday there were midnight performances of *Shuffle Along*," wrote Noel

Halle Berry, 2002

20

Coward in his 1937 memoir, *Present Indicative.* "Throughout the whole jumble of songs and sketches and dances there darted the swift, vivid genius of Florence Mills, at one moment moving like a streak of quicksilver, the next still against some gaudily painted backdrop, nothing animated about her at all, except her wide smile and the little pulse in her throat, throbbing like a bird while she sang." *Shuffle Along* was such a big hit that tourists, like urban anthropologists, wanted to examine the source. So whites began to go to Harlem. And so did blacks from out of town. "To see *Shuffle Along* was the main reason I wanted to go to Columbia," wrote Langston Hughes. Florence Mills, who appeared in one hit after another and was the toast of London where the prince of Wales named her "Little Twinks," died suddenly in 1927, at the age of 31. Her funeral, at Mother Zion Church, was the greatest seen in Harlem. Chorus girls from all the black shows followed her cortege; and at 145th Street, a low-flying plane released a flock of blackbirds. "When she died," wrote Coward, "many thousands of people followed her to the cemetery. Most of Broadway, and all of Harlem. And when the service was over . . . just as the small coffin was being lowered into the grave, a sudden burst of singing rose to the skies, saluting her passing with the song she had made so famous: 'Bye-bye, Blackbird.'"

Arguably, the greatest explosion of negritude in the 1920s and '30s came in the visual arts. Today's racial puritans might see these works, even those by black artists, as "stereotypes"—in reality they should be considered a celebration of blackness, with an emphasis on Africa and African masks. In the tradition of other great social artists like Hogarth, Daumier and Goya, the black and white artists of the Renaissance were more interested in extremely stylized essentialism than individuation. "Winhold Reiss made a portrait of me in colored crayons, and . . . I met a young Mexican artist named Miguel Covarrubias, who was fascinated by Harlem and made wonderful caricatures in rhythm of dancers and blues singers. About that time I met Aaron Douglas, too, and Augusta Savage, the sculptress . . . I began to form my first literary and artistic friendships," wrote Langston Hughes in *The Big Sea,* published in 1940.

Winhold Reiss, a German graphic artist, and Miguel Covarrubias, a Mexican caricaturist, are two of the great non-black figures of the artistic Renaissance. Covarrubias arrived in Harlem from Mexico City in 1923, and Reiss arrived in 1925. In

Jacob Lawrence, 1997

1925, already a star *Vanity Fair* caricaturist, Covarrubias illustrated Langston Hughes' first book of poetry, *Weary Blues*, and created the set designs for *La Revue Nègre*, in Paris, which introduced Josephine Baker. And Winhold Reiss' exhibition of portraits of "Representative Negroes" opened at the Harlem branch of the New York Public Library in 1925. Among the few Renaissance artists who depicted the black middle class, Reiss became the teacher of Aaron Douglas—arguably the greatest of the black negritude-inspired illustrators of the Renaissance. Other names in the artistic Renaissance included that of elder statesman and expatriate Henry Ossawa Tanner and younger figures like Meta Vaux Fuller, Augusta Savage, William H. Johnson, Charles Alston, Palmer Hayden, Romare Bearden, Jacob Lawrence, Richmond Barthe, Archibald J. Motley, and Lois Mailou Jones.

The magic years came to an abrupt end on October 28, 1929, "Black Friday," when Wall Street laid its famous egg. The stock market crash changed Harlem almost overnight. There were fewer VIP tourists—and the repeal of Prohibition in 1933, with the removal of most mob money, was the nail in the coffin for those who liked Harlem best for protected illegality. "That spring for me (and, I guess, all of us) was the end of the Harlem Renaissance. We were no longer in vogue, anyway, we Negroes. Sophisticated New Yorkers turned to Noel Coward . . . The cycle that had charlestoned into being on the dancing heels of *Shuffle Along* now ended in *Green Pastures* with De Lawd." Hughes was too pessimistic. The Jazz Age was over, but Harlem had other attractions: the Age of Swing was about to begin. Instead of bootleg whisky, the great intoxications were "trucking," "jitterbugging," and big bands. And the artists and intellectuals, as well as music and dance-mad tourists, continued to arrive. In 1932, Carl Van Vechten bought a camera and, thankfully, began photographing the great Renaissance figures. Van Vechten's camera was to the black 1930s what James Vanderzee's had been to the 1920s. As Harlem became poorer, it became more politicized. The Communist Party's Harlem foothold was thanks to perennial black Communist Vice-Presidential candidate, James Ford, an ex-World War officer. The 1935 Harlem riot was a horrific watershed event, nearly devastating the community. Yet Harlem's spirit was indestructible— from Lindy-hopping at the Savoy to big band battles between Count Basie and Chick Webb. And Harlem arts continued to flourish

Richard Gant, 1978

under the New Deal; notably, in the theater, with Orson Welles's famous 1936 WPA-sponsored *Black Macbeth*. And two spiritual sons of Harlem, Jesse Owens and Joe Louis, gave America a preview of World War II. While Hitler trumpeted the "master race," Owens took home the Gold at the 1936 Olympics—and in 1938, Joe Louis defeated super Aryan Max Schmeling in under a round, in the symbolic fight of the century. In its elation over Owens and Louis, Harlem could fairly be called "prematurely anti-fascist." Before the 1940s, and the Rev. Adam Clayton Powell Jr.'s "Don't Shop Where You Can't Work" campaign, blacks couldn't work on 125th Street, Harlem's main thoroughfare.

James Weldon Johnson wrote of a Harlem that existed beyond the tourists. This was the Harlem that artists like Al Hirschfeld would continue to look for well after the Renaissance years. "Strolling is a lost art in New York; at least, in the manner in which it is so generally practiced in Harlem," wrote Johnson of a simple Harlem pleasure. "One puts on one's best clothes and fares forth to pass the time pleasantly with the friends and acquaintances and, most important of all, the strangers he is sure of meeting." Al's two "strolling" Harlem families are in the great Renaissance tradition. And both fathers follow black show business fashion: one, in sunglasses and derby, is Bill "Bojangles" Robinson; while the other (with matching son) is Cab Calloway. There is also the underside of Harlem, wrote Johnson: "its world of pimps and prostitutes, of gamblers and thieves, of illicit love and illicit liquor, of red sins and dark crimes." Al's gold-toothed pimp or con man and his drunken prostitute, escorted by a grim-faced policeman, belong to the underside. But Harlem nights still belong to music and entertainment. Al's nights range from Savoy Ballroom dancers to jazz in the small clubs with mostly black clientele. His top-hatted chorus girl might well have been inspired by Lucille Wilson, hired in 1932 on a trial basis (in case customers complained) by the Cotton Club as its first instantly identifiable Negro chorus girl. She later became Mrs. Louis Armstrong. But his enigmatically titled "Seven

Ken Page, *Ain't Misbehavin'*, 1988

23

O'Clock," a study of a lone, tired, woman, reflects another side of the Renaissance—described in the 1925 *Survey*. "Caricature has put upon the countenance of the Negro the mask of the comic and the grotesque, whereas in deeper truth and comprehension, nature or experience have put there the stamp of the very opposite, the serious, the tragic, the wistful." Al saw both sides of the story.

Al Hirschfeld lived until his hundredth year—long enough to see the great Harlem thoroughfares—Lenox, Seventh and Eighth Avenues, renamed Frederick Douglass Boulevard, Adam Clayton Powell, Jr. Boulevard, and Malcolm X Boulevard. (Prosaic as the former names were, they somehow seem more redolent of Harlem history than these great men, only one of whom, Powell, was native to Harlem.) Clearly, they remained in his life—the choice of Fats Waller, ineffable spirit of Harlem charm, singing "Honeysuckle Rose" as part of his memorial music is a hint. In his journey through the twentieth century, Al Hirschfeld always transcended his times and always remained completely himself. He moved beyond the essentialism of the 1920s and '30s to a powerful individualism—one that became both uniquely Hirschfeld and uniquely the person he was capturing—as we see in his drawings of Sidney Poitier, Sammy Davis, Jr., Wynton Marsalis, Ella Fitzgerald, and Ethel Waters, for example.

In the process, the works of Al Hirschfeld became an "all-encompassing catalog" of the twentieth century.

Harold and Fayard Nicholas,
the Nicholas Brothers
Babes in Arms, 1937

The HARLEM PORTFOLIO

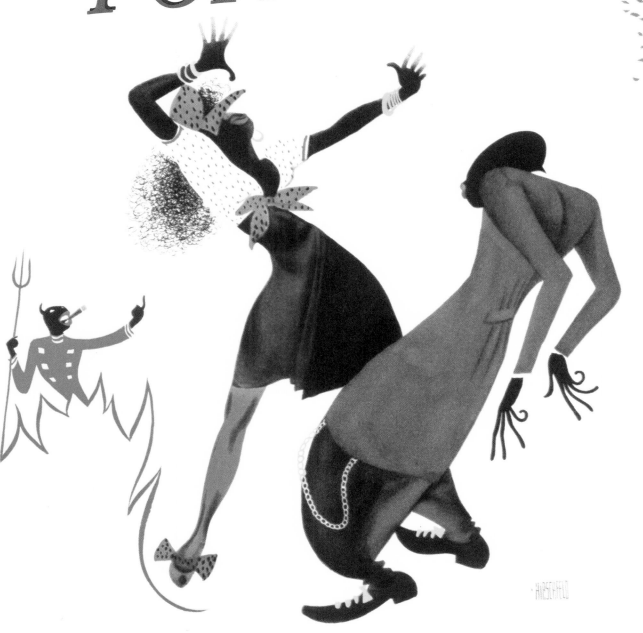

EBONY SISTER

Sister Ebony's face radiates the whole history of Blackness. Her visage reminds one of an African tribal mask wrapped in the sober habit of a Catholic nun. The juxtaposition of cultures, of millennia, is unsettling and profound. The power flowing through her can and has sustained the entire human race. She is the bearer.

Hirschfeld chose this powerfully incongruous figure as the first image of his Harlem portfolio. Sister Ebony witnesses the promenade of Harlemites as they pass before her. She distributes compassion and understanding to the sometimes troubled souls who follow on succeeding pages. Might she also stand as a stern warning at the portal to Harlem about the choices to be made inside this fabled land of the high life?

Here is a woman hardened, no doubt, by life's prejudices. But she is also a woman with the physical and spiritual strength to persevere and prevail, just as Harlem itself has persevered and prevailed. Harlem, as we are reminded on these glorious pages, is justifiably celebrated for its arts—but it is also deeply steeped in spirituality and known for its exuberant liturgy, great charity, and boundless faith.

—Cicely Tyson

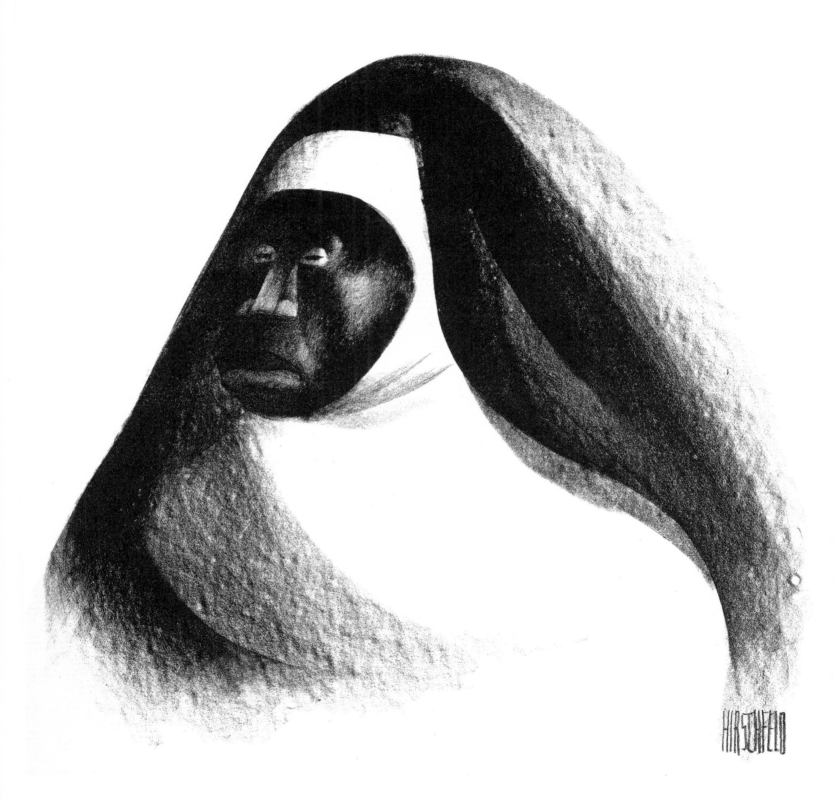

PLASTERED

Here is a Hirschfeld take on an uptown Manhattan after-hours reveler who may be on her way back outside from one of those legendary rent party shindigs where, along with the most fantastic stride (i.e. eastern Ragtime) piano music in the world, the menu featured down-home recipe pig's foot and bottled beer.

Or maybe the venue this time was one or maybe even a sequence of gin mills, cozy hole-in-the wall sip, snack, and jive joints mainly along and between Lenox and St. Nicholas Avenues from, say, 125th Street. On up towards Sugar Hill, where during the Prohibition Era, the joy juice was served under the counter, or (especially in ballrooms) shared from a hip pocket flask by an old friend or would-be friend and/or dancing partner.

Bessie Smith and Billie Holiday, not unlike many other blues divas and red hot mamas, boasted that when they were "in their gin" they became so "sent" (i.e. ecstatic) that they didn't care about anything but the good times they were having.

But Hirschfeld's somewhat over-indulged reveler who is ever so obviously weak in the knees and ankles has not crushed her elegantly plumed hat, and she knows precisely where her purse is!

As for the ever so patient cop, he has not taken her into custody; he's taking her home if she lives in his precinct and to a cab or bus if she lives elsewhere. After all, a good uptown cop in those good old days knew that good business was good for his precinct. Nor did his civic pride go unacknowledged by the local business establishment.

—Albert L. Murray

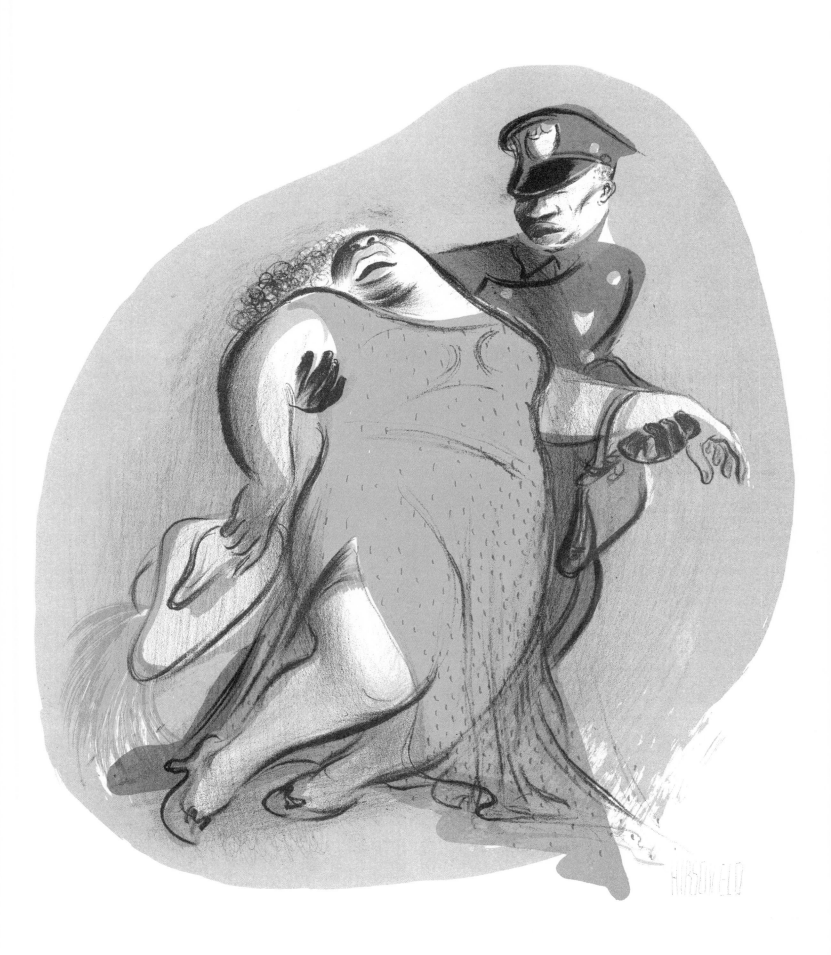

REEFER MAN

Sleek . . . intimate . . . timeless . . . ➜

 Just like Hirschfeld . . . this

Portrait of "The Reefer Man" immediately

Reminds me of <u>the</u> coolest . . . most hip . . . Cats uptown . . .

From sunrise to sunset . . . These cats sincerely kept their styles

Above water . . . Always a couple of steps ahead of the laws . . .

Timeless . . . Intimate . . . Sleek . . . ➜

 Just like Hirschfeld ➜ this portrait is wreakin' that potent

Harlem reefer man attitude . . . One couldn't help but to notice

Hirschfeld's uncanny sense of humor ➜

Thanx 4 The reefer man . . .

 Ya dig ➜

—Savion Glover

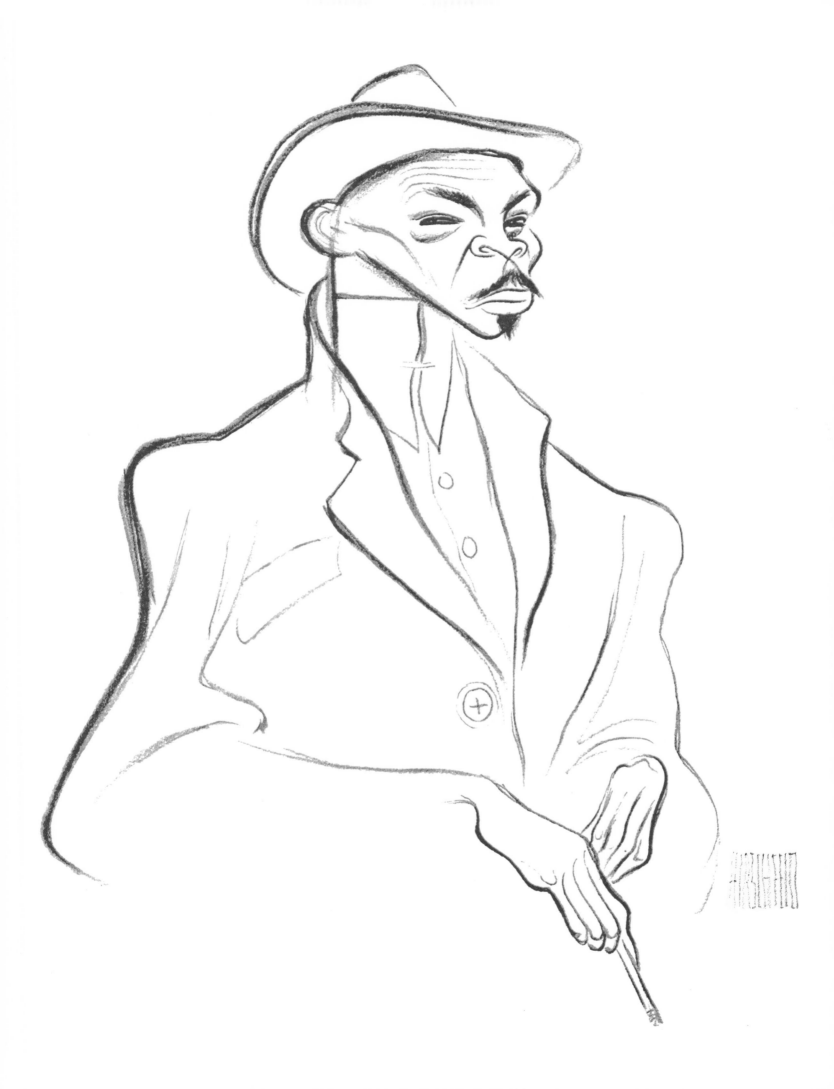

LINDY HOP

As a native New Yorker, native-born, this picture certainly has resonance for me. It conjures up memories of my growing up in the magical neighborhood of Harlem—and attending some of the best parties ever at the Savoy and Renaissance Ballrooms.

My introduction to dance was winning a dance contest at Junior High School 43—I danced the Lindy. It prompted one of my teachers to recommend me to the High School of Performing Arts. And the rest, as they say, is history.

The Lindy Hop is a dance infused with ingenuity, rhythm, freedom and joy. These characteristics embody the essence of the community of Harlem.

As I travel around the world, I marvel at the love and admiration spoken of Harlem in a dozen languages. There is a mystique about Harlem that one yearns to experience. What they discover is a Mecca of spirited people with a rich culture and outstanding achievement.

—Arthur Mitchell
DANCE THEATRE OF HARLEM

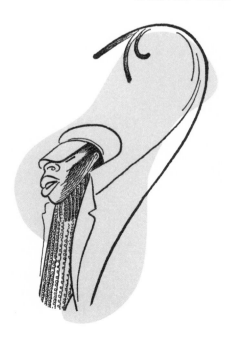

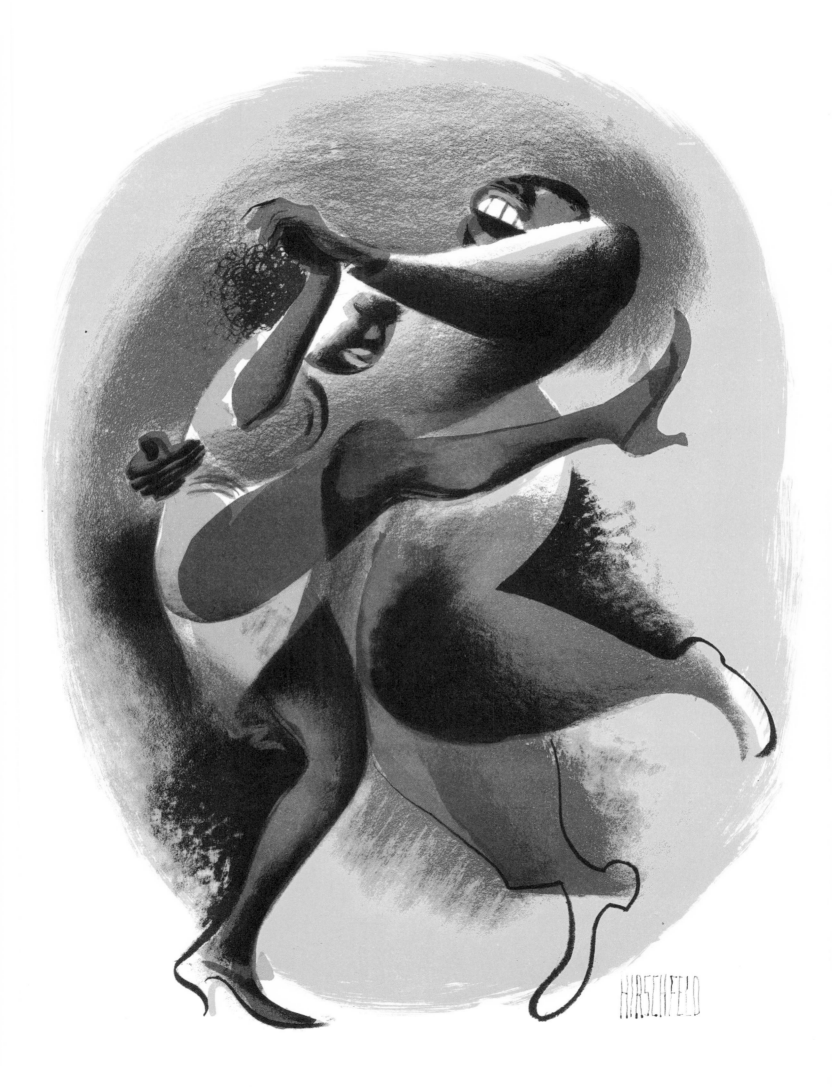

SOLID SENDER

—Quincy Jones

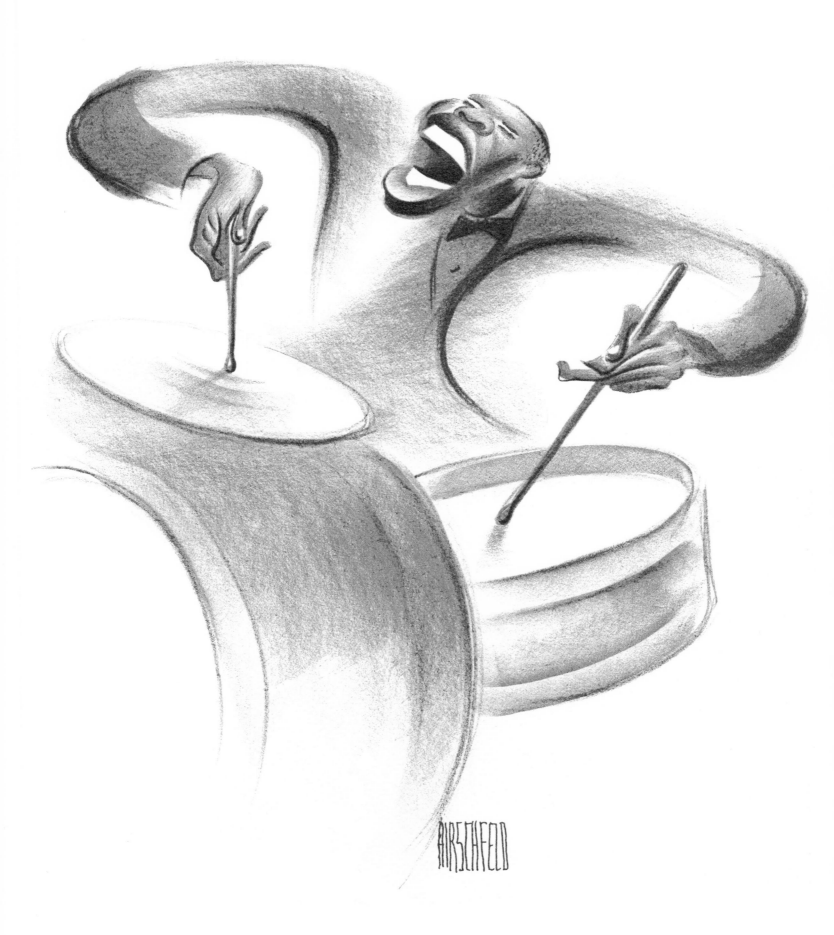

SCUFFLIN' IN

In a country otherwise populated by ladies wearing white gloves, Harlem was probably one of the most liberated neighborhoods in existence. True, Harlemites were largely restricted socially to their environs, but they were also liberated by them, and by their own innovation.

The couple in SCUFFLIN' IN is dynamic just standing still. This sensuous sway of dancing started by liberating Harlem, but from here, it eventually liberated the whole nation. And dig that crazy zoot suit the gent is wearing. Dance and music were being transformed on a nearly nightly basis in Harlem during this very musical era at places like the Savoy Ballroom and Baron Wilkins.

Al Hirschfeld makes us want to break out into verse:

> *SCUFFLIN' IN Reminds Us Of A*
> *Symphony of Spirits*
> *An Unabashed Coming Together*
> *Of the Universal Life Forces*
> *That Propels and Inspires Us*
> *Toward Divine Goals*

—Ruby Dee and Ossie Davis

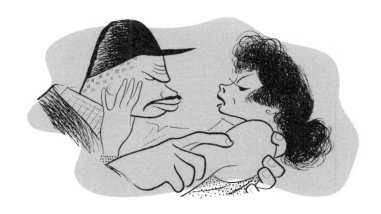

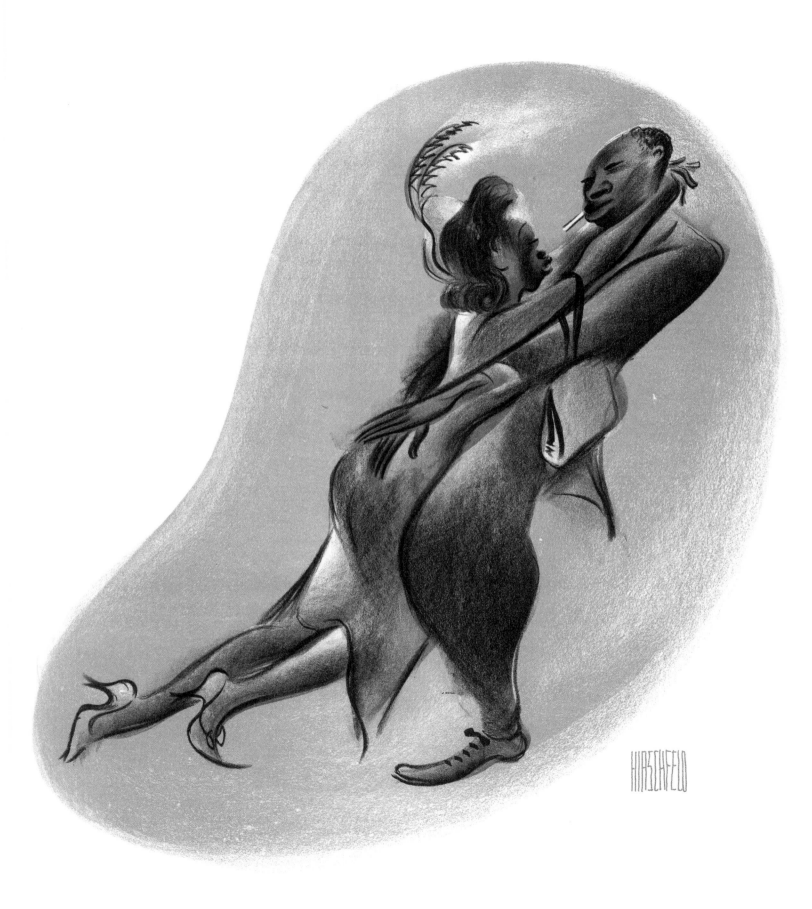

BOOGIE WOOGIE

BOOGIE WOOGIE simply comes alive the longer one gazes at it. How many times before you have witnessed that smile of sheer ecstasy on the face of the gentleman on the right? How about his partner's cool—and, indeed, how about that behind? The couple to the left tell it all exactly the way it is. I love the clothes, the movement, the very funk of it all.

By framing his swaying dancers in that archway, Hirschfeld allows us to share his own sense of intimacy, and we are vouchsafed a glimpse of a modern ritual not exactly open to the general public. With the dancers' postures, Hirschfeld conveys how very long this ritual has been going on, and that these people are in a sense captured in their rapture, unable to stop however exhausted they feel.

BOOGIE WOOGIE is a moving metaphor for many Harlemites in this difficult era, the tail end of the Depression. They had little besides their new music and the pleasure derived from their bodies. As exhilarating as all that was, they were still prisoners of their troubles. Through music and the dance they could escape from their everyday hardship for as long as they could keep up with the beat. The end result is a piece of Harlem that will not and cannot be reprised.

North of Central Park in this era attracted my friend Al Hirschfeld as it had countless others, all inspired by the allure of a Harlem where joy was the password and glamour was the order of the day and night.

—Bobby Short

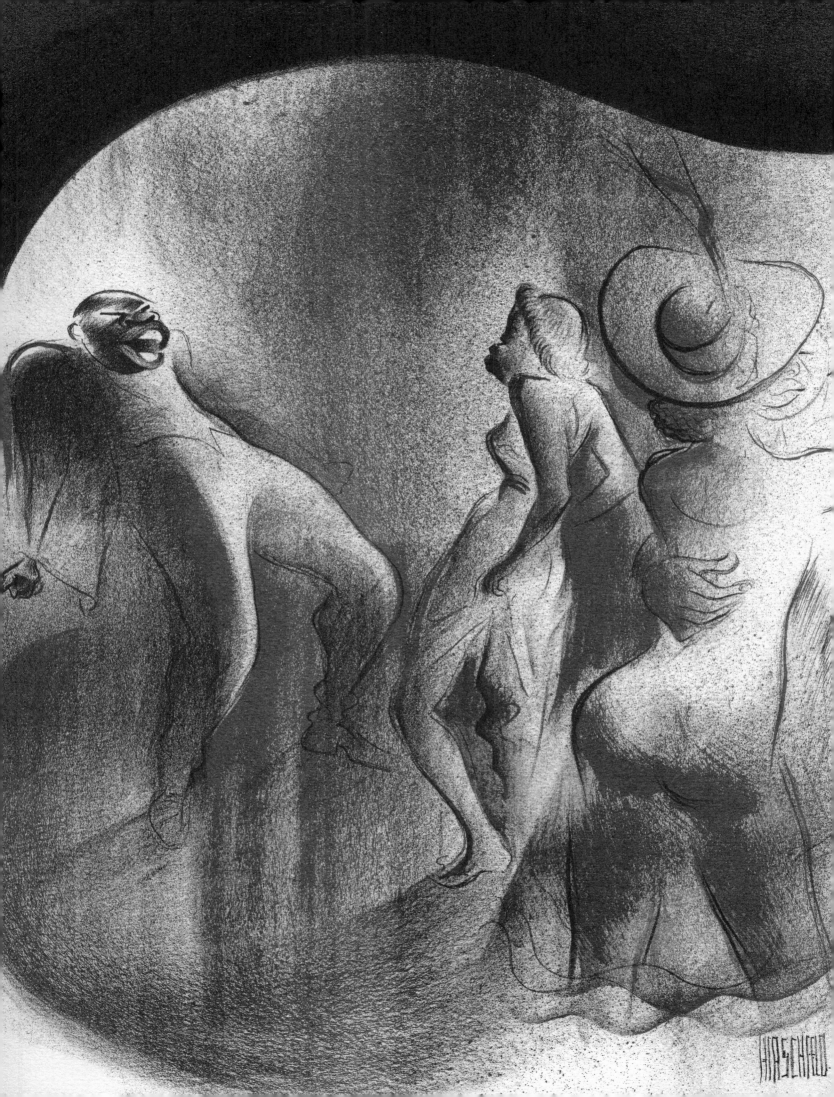

NUMBERS KING

Taps on his feet
Hittin' the pavement with a clean beat
Walkin' bass thumpin' in his chest
Tuxedo jacket in a grand piano hand

A trumpet blast flash of a smile
The sax section risin' behind those eyes
A muted trombone slippery slides:
"Hey, Sweet Thang, you sho' look fine!"

The Numbers King is with us once again
Walkin' down the street
 like a Big Band.

—Brian Stokes Mitchell

SEVEN O'CLOCK

The title is mysterious and she is mysterious. Is it seven AM or PM? Is she a working woman or a working girl? Has she been working all night? Or working all day? She is definitely tired. I don't think she's a real Harlemite. I think she's newly arrived from the South. She hasn't quite got the Harlem style. The real Harlem style—the girls I worked with at the Cotton Club had no money, but they *had* it. She looks worn down by life and can't afford to get her hair done. She looks a little defeated. She reminds me of Langston Hughes' "Miss Blues'es Child":

> *If the blues would let me,*
> *Lord knows I would smile.*
> *If the blues would let me,*
> *I would smile, smile, smile.*
> *Instead of that I'm cryin'—*
> *I must be Miss Blues'es child.*

—Lena Horne

LENOX AVENUE STROLL

It's Sunday. We are so clean. We are a family. We are the generation of today standing between two other periods of time. We are both dreams and expression of our parents linking us to their past. Our dreams for the young one links us to the future. It's Sunday. We are so clean. Do you know what I mean?

—Chester Higgins Jr.

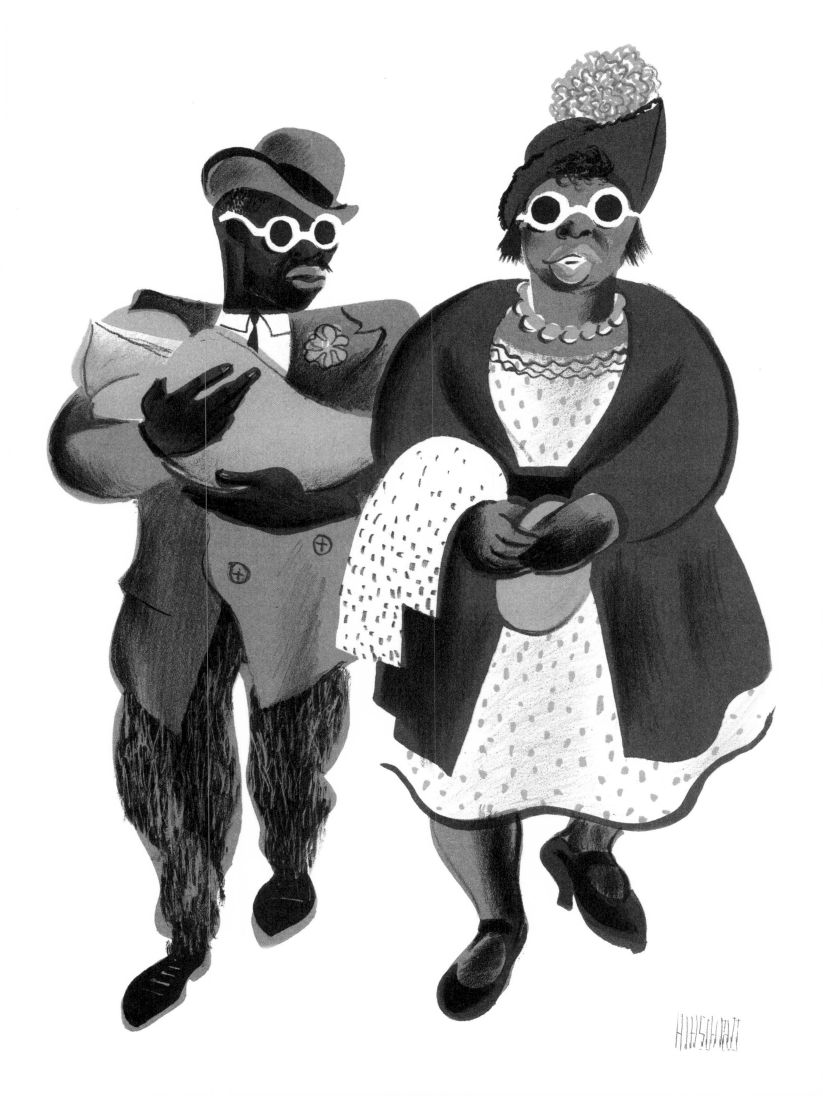

SUGAR HILL STATESMAN

I can't help but recall a Congressional predecessor of mine from Harlem—the flamboyant, courageous, innovative, controversial and unfailingly entertaining, Adam Clayton Powell, Jr. It was just about the time *Hirschfeld's Harlem* first came out, 1941, that Powell—an extremely charismatic figure—was elected to the New York City Council. Four years later, he became the first African American elected from Harlem to the United States House of Representatives.

Powell was a powerful, early voice in the national government for Civil Rights. He had the good fortune to remain in the Congress until his dream, the Civil Rights Act, was enacted in 1964. That bill was, in fact, a version of his own earlier Powell Amendment.

Every politician needs a little flamboyance to float his message across. And in Harlem, style is a currency all its own. There are days when style lifts you above all your troubles. Hirschfeld has magically combined that chemistry of pride and purpose. He has captured as well the joy and burgeoning desires of Harlemites at this crucial juncture in their history, when the march to freedom was just taking its first real steps. Studying SUGAR HILL STATESMAN today reminds us that we still have a far way to go and much yet to accomplish.

—Congressman Charles B. Rangel

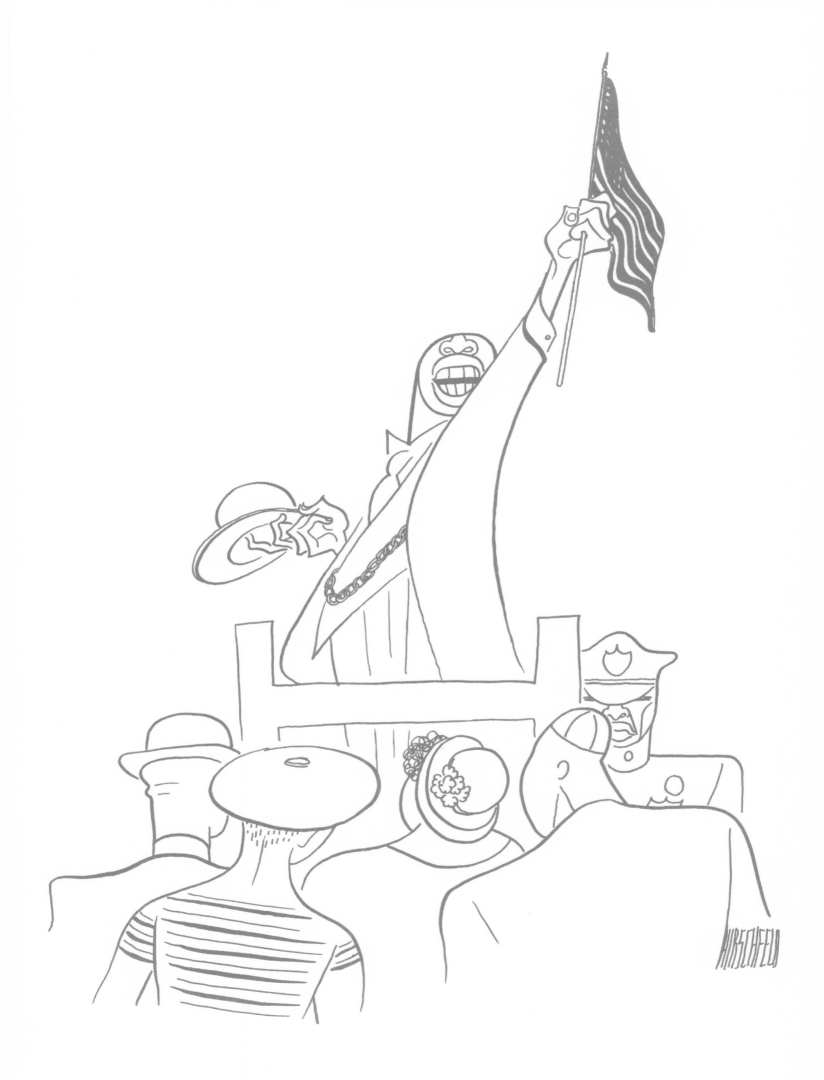

APOLLO CHORINE

I looked into the shallow bowl of the old spoon and saw my
entire life swimming in black wax.

Each bead I string along my lashes is heavy with memories

 Of

Full houses, empty seats, bad lighting, enthusiastic audiences,
Splintered floors, missed steps, cold dressing rooms, generous
 partners,
Smiles, tears, anticipation, ecstasy, envy jealousy, failures,
 friendships.

All this and more—

 in one small teaspoon of beading.

—Carmen de Lavallade

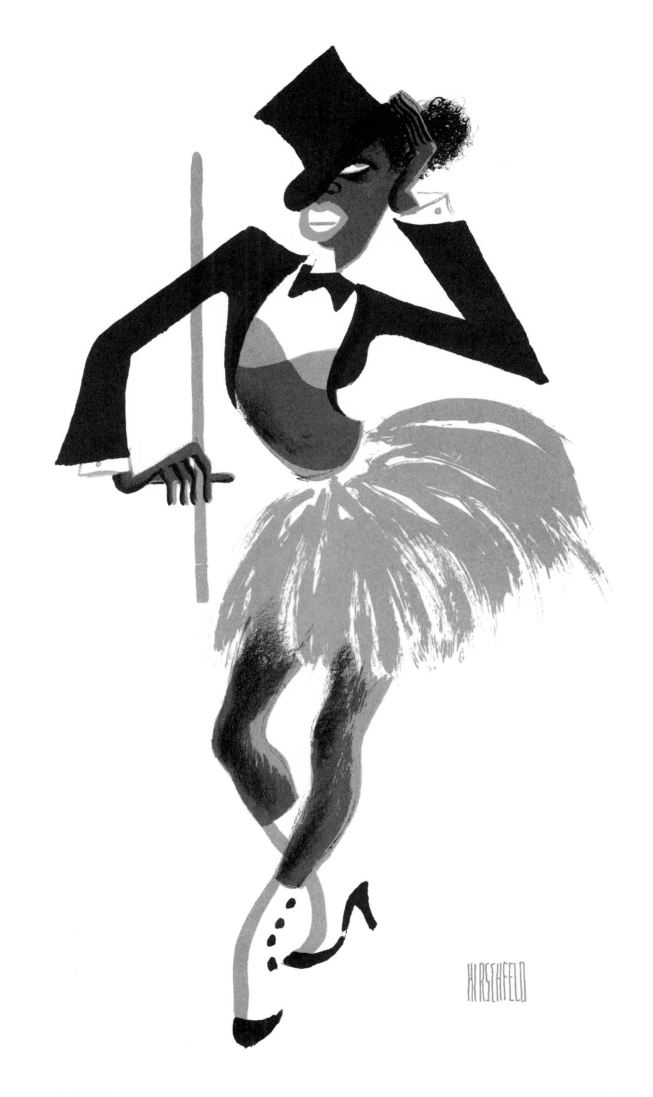

YEAH, MEN!

You have a good idea
what to tell the flock this week,
but surprise! The Holy Spirit says,
"Stand back and let me speak!"

Closed eyes and praying hands
bespeak a rapturous union.
The congregation waits in awe—
what blessed, sweet communion!

Grace-filled words come tumbling out.
They make the whole place shiver.
All the people shout "Amen!"
and joy flows like a river.

—Reverend Dr. James A. Forbes, Jr.
THE RIVERSIDE CHURCH

JAM SESSION

Most of these sessions evaporated into the thin early morning Harlem air, but this one resonates beyond that back room, throughout eternity. The great master of line is off on his own solo, capturing the vibe, the soul of these jazz musicians.

Al was a wonderful drummer in those days. These gents may be having a hard time keeping up with his Timpani with Pen and Brush. Al is sitting in, jamming, and not sitting back either.

That was part of Hirschfeld's gift. He didn't lean back, he leaned in. He didn't record, he soared. In 1957 he drew me dancing (in rather a scanty costume) as an African King in *Showboat*. My body glided across the page of *The New York Times* as it never did on stage. He knew my body language better than my understudy. Better perhaps than I ever did myself.

—Geoffrey Holder

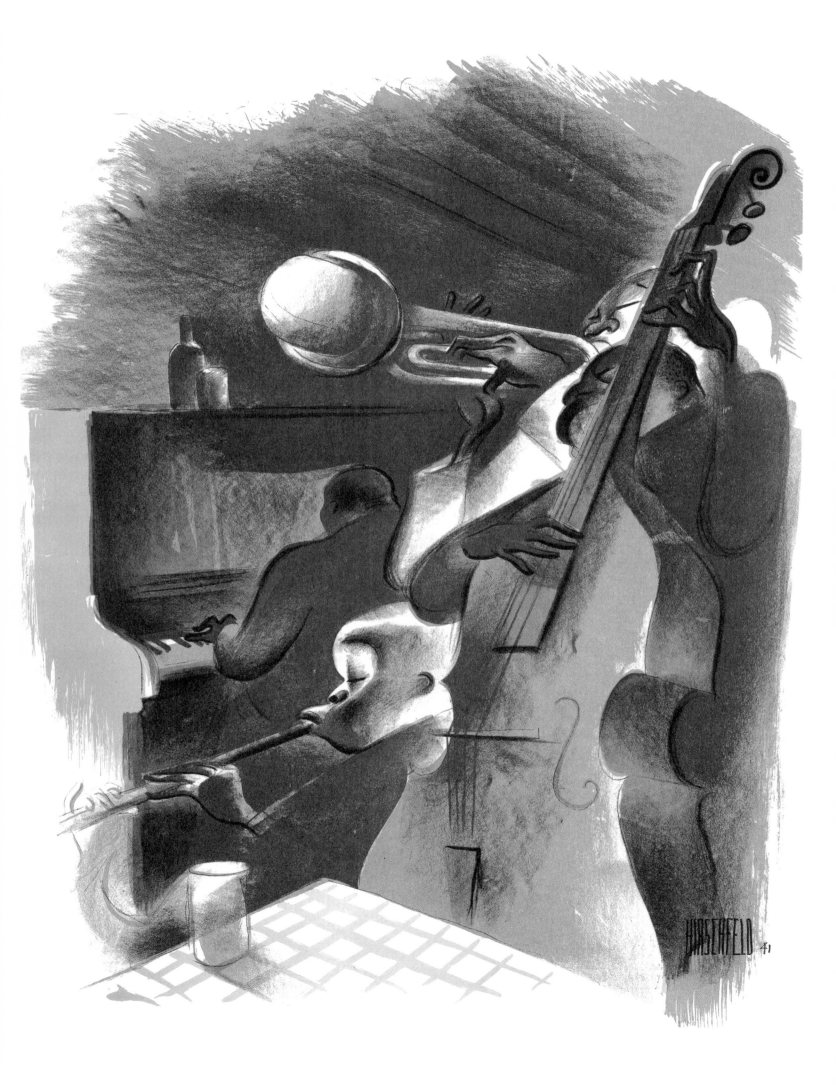

THE DINNER

He's late again. That's it! I'm leavin'! Well, I'm gonna wait five more minutes. I been waitin' long enough. Spent all afternoon at the beauty shop. Got my grandmamma's pearls on. This here is my finest dress and my feet are startin' to hurt in these shoes.

Where is that man? Big night, he said. Special night, he said. Important night, he said. I been practicin' my "I do." Well, just maybe I'll say "I won't!"

That's it. I'm leavin' . . . after five more minutes.

—Audra McDonald

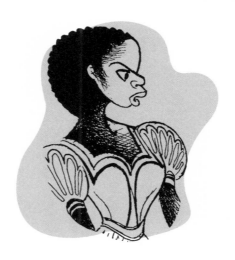

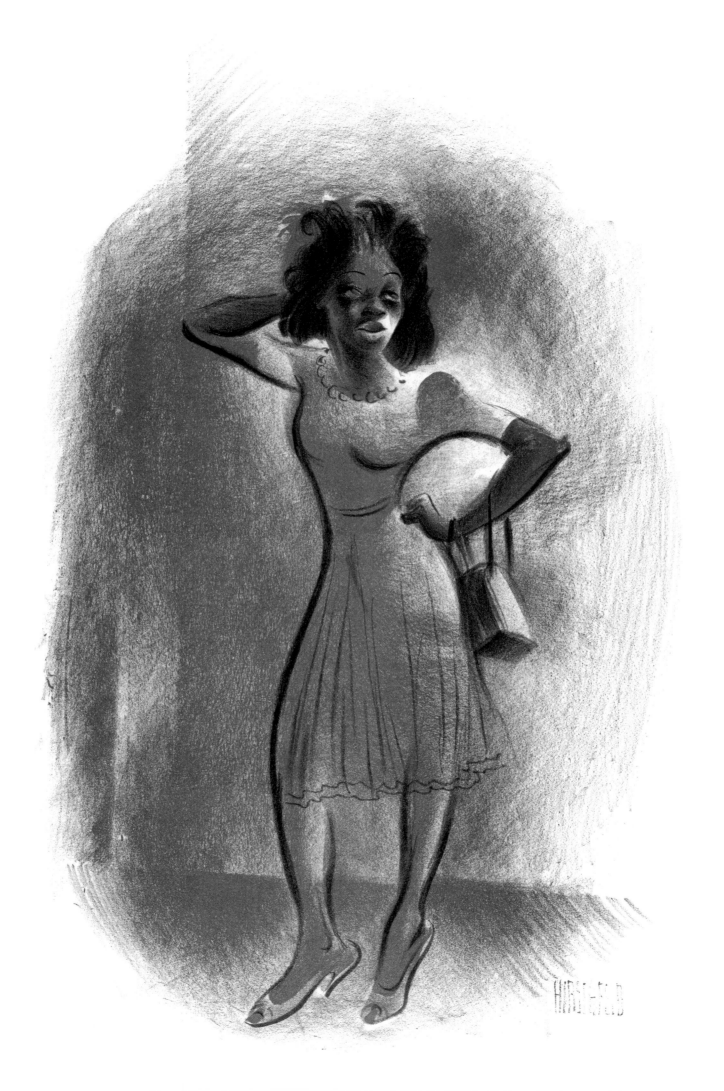

SHARPY FAMILY

When you look at this Hirschfeld you know it's Sunday afternoon on the promenade in Harlem, an historical Harlem that exists in photographs and memories of old Harlem residents. Sundays were the days when maids, deliverymen, mechanics and hairdressers who were invisible downtown, became visible socialites and peacocks wearing the latest fashions and trends—contrary to the movie stereotypes of the time.

 The family unit out walking the Harlem promenade.
Listen . . . can't you hear the music of Duke or Cab? Hey, maybe they are on their way to dinner or maybe they are just out for a stroll. So proud and beautiful, knowing that on Monday as they head back to work downtown, assuming the cloak of invisibility once more, they live in a world, a microcosm, which few knew; a magical world that came to life on Sundays on the promenade in Harlem.

 Al gives us a visual insight into our past and I can't thank him enough.

<div align="right">

—Whoopi Goldberg

</div>

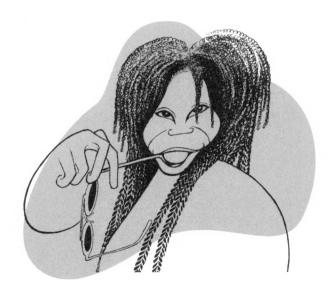

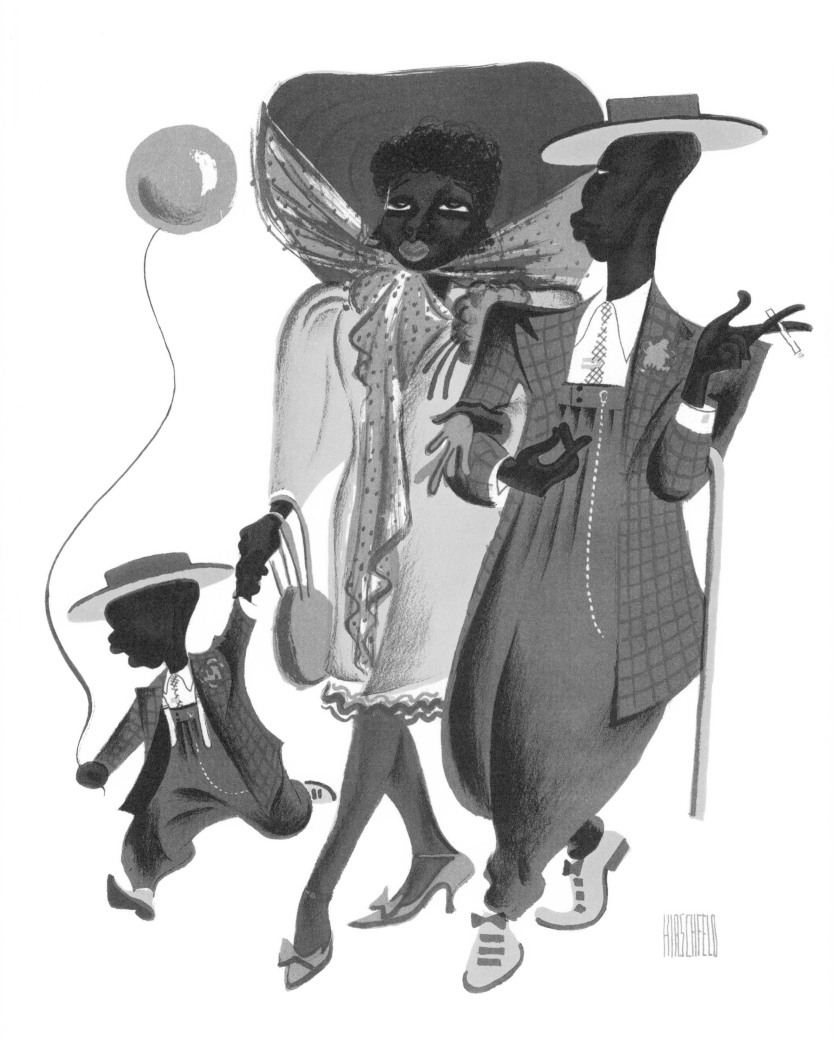

SLOW BLUES

SLOW BLUES is sensual, elegant, stylish, playful and very, very sly. It brilliantly captures that time of the night when Saturday night vanity gives way to passion and need.

During the week these people exist in defiance of society's definition of who they are, but come Saturday night, they are their own uncompromising elegant selves.

Such was/is the power of blues. Such was/is the power of Harlem and the people who live there.

And Hirschfeld captured it all.

—George C. Wolfe
THE NEW YORK SHAKESPEARE
FESTIVAL

COCOA VENUS

I feel the warm affection Hirschfeld must have felt for Harlem, African American women, and women in general. I feel the warmth and sensuality of this particular woman, the great feeling of her beauty. The spirituality of her soul reads through her whole body. Her hands, her long fingers are so expressive as though to say "my lover has just left and I can't wait for his return."

I reach out and feel the nubby pale paint on that old Thirties cast-iron bed frame. And the wallpaper—I feel like I could turn around, open the door and walk right into this Harlem boarding house. No trouble imagining how special Al Hirschfeld must have felt to discover Cocoa Venus in 1941.

Cocoa Venus, wherever you are, keep on waiting. Your lover is coming home!

—Eartha Kitt

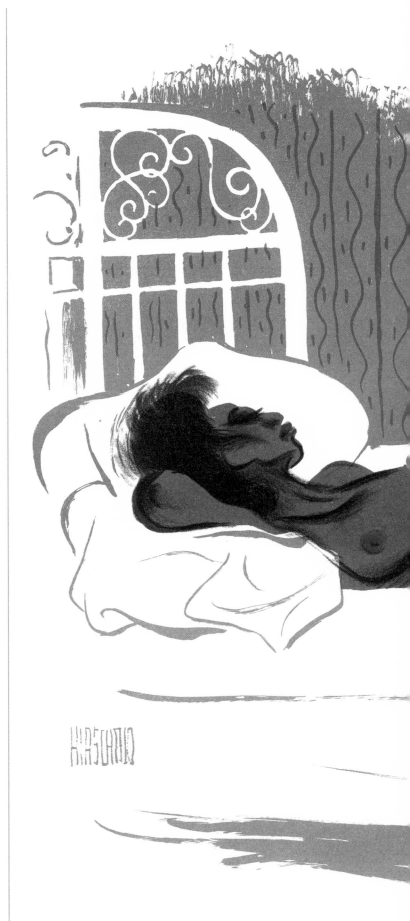

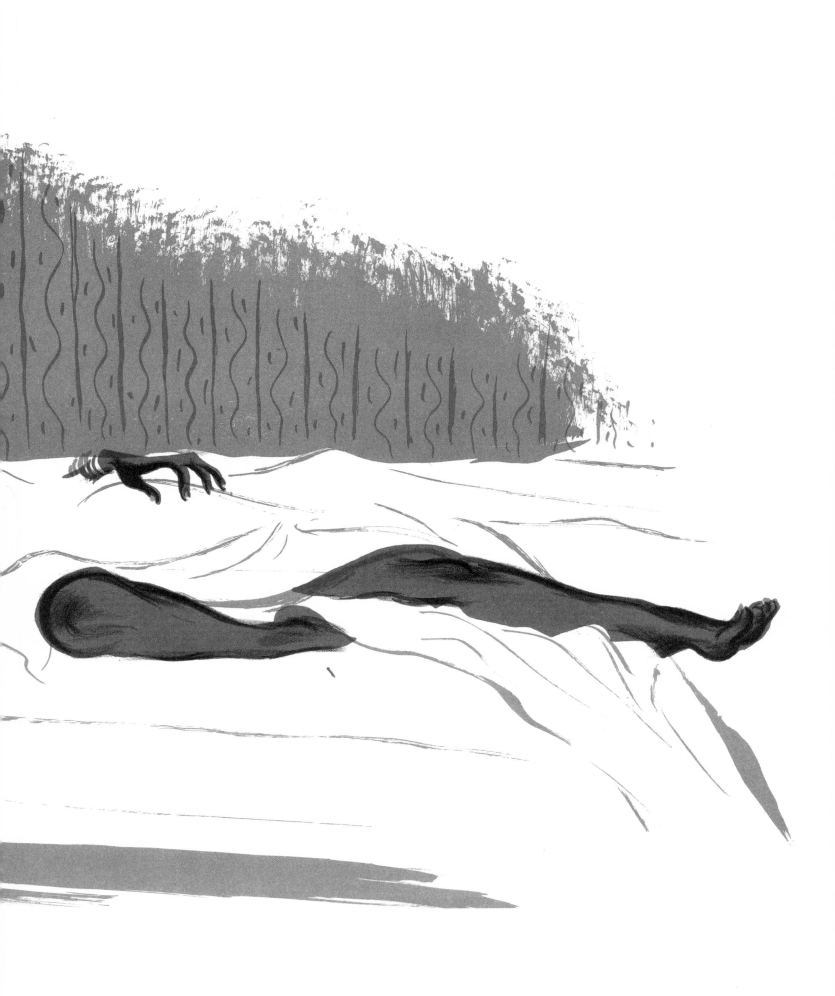

STOMPIN' AT THE SAVOY

Al Hirschfeld recognized beauty and artistic genius when he saw it. Walking the streets of Harlem, frequenting its establishments, seeing its sights and listening to its sounds, he discovered its inner beauty, life and vitality and depicted it in his signature artistic style. Photographs of the period confirm the authority and authenticity of his vision. His interpretations of Harlem's reality record images that no photograph could quite capture. His art celebrated Harlem's and Harlemites' unique cultural and aesthetic style— the way Harlemites would stand, walk, dress, look and dance.

The world-famous Savoy Ballroom was the epicenter of Harlem's dance world. The thousands of revelers who would gather nightly in the block-long dance hall invented many of the dances that would make Harlem and the Savoy famous. But the Savoy was more than a dance hall. It was one of the stages on which Harlemites sported their fashions and their attitudes as they danced to the big band sounds of Louis Armstrong, Chick Webb, Fletcher Henderson, and Duke Ellington, to mention just a few.

The music never stopped at the Savoy. Neither did the dancing. Hirschfeld's STOMPIN' AT THE SAVOY reveals Harlem's aesthetics, style and attitudes at their finest.

—Howard Dodson
THE SCHOMBURG CENTER

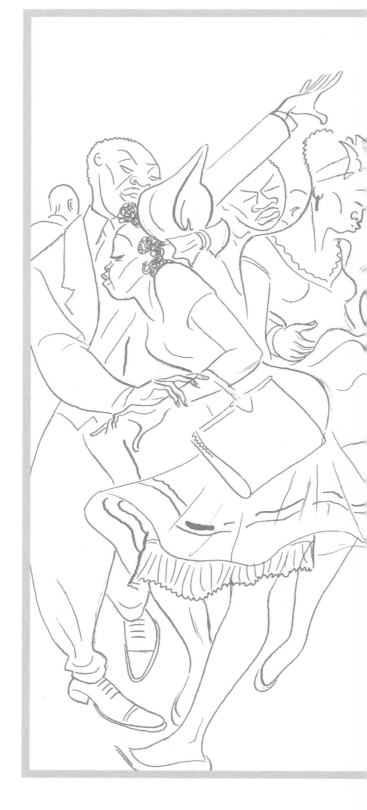

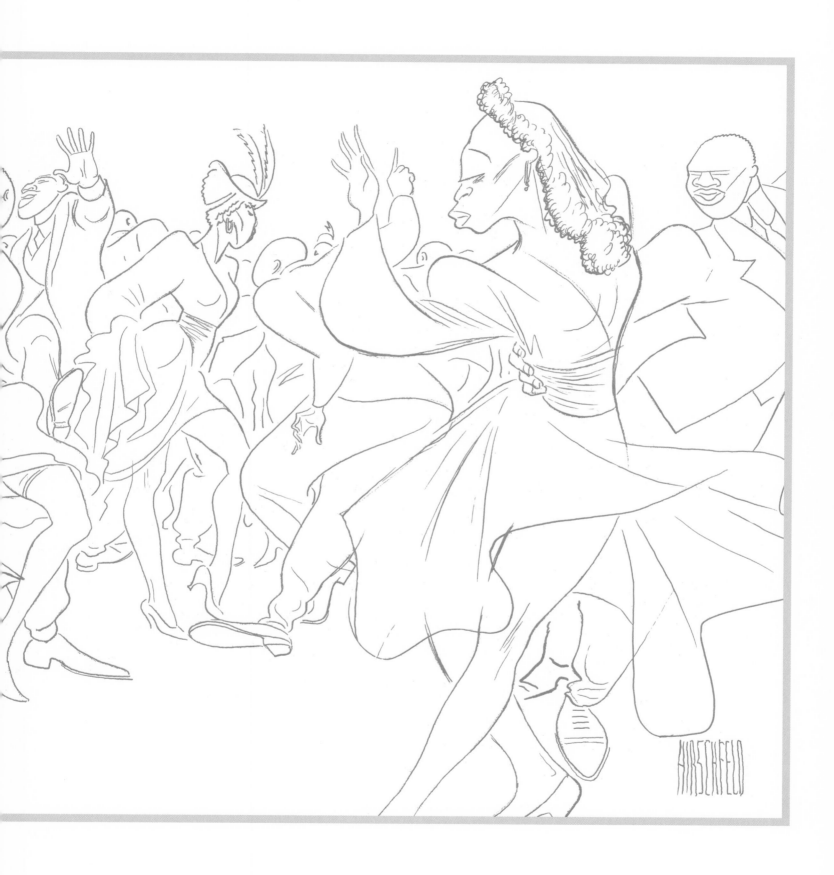

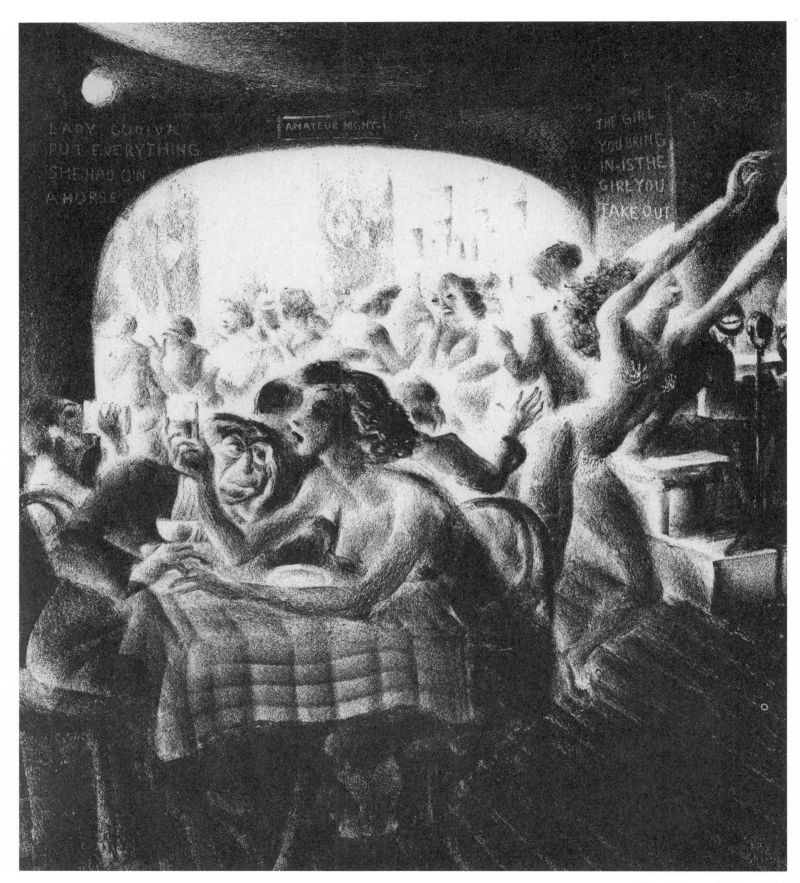

The Dizzy Club, 1931

Story in Harlem Slang

ZORA NEALE HURSTON

New York's Harlem, the nation's largest Negro community, is a city within a city: an amazing place of beauty and squalor, heaped-up hopes and despairs. Out of Harlem comes a constant flow of legend, music and picturesque language which has deeply influenced American life. Miss Hurston has for many years studied the curious and colorful argot of Harlem which has enriched the American vocabulary. Here she offers a sketch of Harlem life couched in Harlemese, together with a glossary of this slang based on her research. The drawings are the work of the gifted Albert Hirschfeld. —THE AMERICAN MERCURY EDITORS

JULY, 1942

Wait till I light up my coal-pot and I'll tell you about this Zigaboo called Jelly. Well, all right now. He was a sealskin brown and papa-tree-top-tall. Skinny in the hips and solid built for speed. He was born with this rough-dried hair, but when he laid on the grease and pressed it down overnight with his stocking-cap, it looked just like that righteous moss, and had so many waves you got seasick from looking. Solid, man, solid!

His mama named him Marvel, but after a month on Lenox Avenue, he changed all that to Jelly. How come? Well, he put it in the street that when it came to filling that long-felt need, sugar-curing the ladies' feelings, he was in a class by himself and nobody knew his name, so he had to tell 'em. "It must be Jelly, 'cause jam don't shake." Therefore, his name was Jelly. That was what was on his sign. The stuff was there and it was mellow. Whenever he was challenged by a hard-head or a frail eel on the right of his title he would eye-ball the idolbreaker with a slice of ice and put on his ugly-laugh, made

up of scorn and pity, and say: "Youse just dumb to the fact, baby. If you don't know what you talking 'bout, you better ask Granny Grunt. I wouldn't mislead you, baby. I don't need to—not with the help I got." Then he would give the pimp's[1] sign, and percolate on down the Avenue. You can't go behind a fact like that.

Conk Buster

So this day he was airing out on the Avenue. It had to be late afternoon, or he would not have been out of bed. All you did by rolling out early was to stir your stomach up. That made you hunt for more dishes to dirty. The longer you slept, the less you had to eat. But you can't collar nods all day. No matter how long you stay in bed, and how quiet you keep, sooner or later that big gut is going to reach over and grab that little one and start to gnaw. That's confidential right from the Bible. You got to get out on the beat and collar yourself a hot.

So Jelly got into his zoot suit with the reet pleats and got out to skivver around and do himself some good. At 132nd Street, he spied one of his colleagues on the opposite sidewalk, standing in front of a café. Jelly figured that if he bull-skated just right, he might confidence Sweet Back out of a thousand on a plate. Maybe a shot of scrap-iron or a reefer. Therefore, Jelly took a quick backward look at his shoe soles to see how his leather was holding out. The way he figured it after the peep was that he had plenty to get across and maybe do a little more cruising besides. So he stanched out into the street and made the crossing.

"Hi, there, Sweet Back!" he exploded cheerfully. "Gimme some skin!"

"Lay de skin on me, pal!" Sweet Back grabbed Jelly's outstretched hand and shook hard. "Ain't seen you since the last time, Jelly. What's cookin'?"

"Oh, just like de bear—I ain't nowhere. Like de bear's brother, I ain't no further.

Like de bear's daughter—ain't got a quarter."

Right away, he wished he had not been so honest. Sweet Back gave him a top-superior, cut-eye look. Looked at Jelly just like a showman looks at an ape. Just as far above Jelly as fried chicken is over branch water.

[1] In Harlemese, pimp has a different meaning than its ordinary definition as a procurer for immoral purposes. The Harlem pimp is a man whose amatory talents are for sale to any woman who will support him, either with a free meal or on a common law basis; in this sense, he is actually a male prostitute.

66

"Cold in hand, hunh?" He talked down to Jelly. "A red hot pimp like you *say* you is, ain't got no business in the barrel. Last night when I left you, you was beating up your gums and broadcasting about how hot you was. Just as hot as July-jam, you told me. What you doing cold in hand?"

"Aw, man, can't you take a joke? I was just beating up my gums when I said I was broke. How can I be broke when I got de best woman in Harlem? If I ask her for a dime, she'll give me a ten dollar bill; ask her for a drink of likker, and she'll buy me a whiskey still. If I'm lying, I'm flying!"

"Gar, don't hang out dat dirty washing in my back yard! Didn't I see you last night with dat beat chick, scoffing a hot dog? Dat chick you had was beat to de heels. Boy, you ain't no good for what you live."

Blow Top

"If you ain't lying now, you flying. You ain't got de first thin. You ain't got nickel one."

Jelly threw back the long skirt of his coat and rammed his hand down into his pants pocket. "Put your money where your mouth is!" he challenged, as he mock-struggled to haul out a huge roll. "Back your crap with your money. I bet you five dollars."

Sweet Back made the same gesture of hauling out nonexistent money.

"I been raised in the church. I don't bet, but I'll doubt you. Five rocks!"

"I thought so!" Jelly crowed, and hurriedly pulled his empty hand out of his pocket. "I knowed you'd back up when I drawed my roll on you."

"You ain't drawed no roll on me, Jelly. You ain't drawed nothing but your pocket. You better stop dat boogerbooing. Next time I'm liable to make you do it." There was a splinter of regret in his voice. If Jelly really had had some money, he might have staked him, Sweet Back, to a hot. Good Southern cornbread with a piano on a platter. Oh, well. The right broad would, or might, come along.

"Who boogerbooing?" Jelly snorted.

Chippie and Child

"Jig, I don't have to. Talking about *me* with a beat chick scoffing a hot dog! You must of not seen me, 'cause last night I was riding round in a Yellow Cab, with a yellow gal, drinking yellow likker and spending yellow money! Tell 'em 'bout me, tell 'em!"

"Git out of my face, Jelly! Dat broad I seen you with wasn't no pe-ola. She was one of them coal-scuttle blondes with hair just as close to her head as ninety-nine is to a hundred. She look-ted like she had seventy-five pounds of clear bosom, guts in her feet, and she look-ted like six months in front and nine months behind. Buy you a whiskey still! Dat broad couldn't make the down payment on a pair of sox."

"Sweet Back, you fixing to talk out of place." Jelly stiffened.

"If you trying to jump salty, Jelly, that's your mammy."

"Don't play in de family, Sweet Back. I don't play de dozens. I done told you."

"Who playing de dozens? You trying to get your hips up on your shoulders 'cause I said you was with a beat broad. One of them lam blacks."

"Who? Me? Long as you been knowing me, Sweet Back, you ain't never seen me with nothing but pe-olas. I can get any frail eel I wants to. How come I'm up here in New York? You don't know, do you? Since youse dumb to the fact, I reckon I'll have to make you hep. I had to leave from down south 'cause Miss Anne used to worry me so bad to go with me. Who, me? Man, I don't deal in no coal. Know what I tell 'em? If they's white, they's right! If they's yellow, they's mellow! If they's brown, they can stick around. But if they come black, they better git back! Tell 'em bout me!"

"Aw, man, you trying to show your grandma how to milk ducks. Best you can do is to confidence some kitchen-mechanic out of a dime or two. Me, I knocks de pad with them cack-broads up on Sugar Hill, and fills 'em full of melody. Man, I'm quick death and easy judgment. Youse just a home-boy, Jelly. Don't try to follow me."

"Me follow *you*! Man, I come on like the Gang Busters, and go off like The March of Time! If dat ain't so, God is gone to Jersey City and you know He wouldn't be messing 'round a place like that. Know what my woman done? We hauled off and went to church last Sunday, and when they passed 'round the plate for the *penny* collection, I threwed in a dollar. De man looked at me real hard for dat. Dat made my woman mad, so she called him back and threwed in a twenty dollar bill! Told him to take dat and go!

Dat's what he got for looking at me 'cause I throwed in a dollar."

"Jelly, de wind may blow and de door may slam; dat what you shooting ain't worth a damn!"

Jelly slammed his hand in his bosom as if to draw a gun. Sweet Back did the same.

"If you wants to fight, Sweet Back, the favor is in me."

"I was deep-thinking then, Jelly. It's a good thing I ain't short tempered. 'T'aint nothing to you, nohow. You ain't hit me yet."

Both burst into a laugh and changed from fighting to lounging poses.

"Don't get too yaller on me, Jelly. You liable to get hurt some day."

"You over-sports your hand your own self. Too blamed astorperious. I just don't pay you no mind. Lay de skin on me!"

They broke their handshake hurriedly, because both of them looked up the Avenue and saw the same thing. It was a girl and they both remembered that it was Wednesday afternoon. All of the domestics off for the afternoon with their pay in their pockets. Some of them bound to be hungry for love. That meant a dinner, a shot of scrap-iron, maybe room rent and a reefer or two. Both went into the pose and put on the look.

"Big stars falling!" Jelly said out loud when she was in hearing distance. "It must be just before day!"

"Yeah, man!" Sweet Back agreed. "Must be a recess in Heaven—pretty angel like that out on the ground."

The girl drew abreast of them, reeling and rocking her hips.

"I'd walk clear to Diddy-Wah-Diddy to get a chance to speak to a pretty lil' ground-angel like that," Jelly went on.

"Aw, man, you ain't willing to go very far. Me, I'd go slap to Ginny-Gall, where they eat cow-rump, skin and all."

The girl smiled, so Jelly set his hat and took the plunge.

"Baby," he crooned, "what's on de rail for de lizard?"

The girl halted and braced her hips with her hands. "A Zigaboo down in Georgy, where I come from, asked a woman

Pimp

69

that one time and the judge told him 'ninety days.'"

"Georgy!" Sweet Back pretended to be elated. "Where 'bouts in Georgy is you from? Delaware?"

"Delaware?" Jelly snorted. "My people! My people! Free schools and dumb jigs! Man, how you going to put Delaware in Georgy? You ought to know dat's in Maryland."

"Oh, don't try to make out youse no northerner, you! Youse from right down in 'Bam your own self!" The girl turned on Jelly.

"Yeah, I'm *from* there and I aims to stay from there."

"One of them Russians, eh?" the girl retorted. "Rushed up here to get away from a job of work."

That kind of talk was not leading towards the dinner table.

"But baby!" Jelly gasped. "Dat shape you got on you! I bet the Coca Cola Company is paying you good money for the patent!"

The girl smiled with pleasure at this, so Sweet Back jumped in.

"I know youse somebody swell to know. Youse real people. You grins like a regular fellow." He gave her his most killing look and let it simmer in. "These dickty jigs round here tries to smile. S'pose you and me go inside the café here and grab a hot?"

"You got any money?" the girl asked, and stiffened like a ramrod. "Nobody ain't pimping on me. You dig me?"

"Aw, now, baby!"

"I seen you two mullet-heads before. I was uptown when Joe Brown had you all in the go-long last night. Dat cop sure hates a pimp! All he needs to see is the pimps' salute, and he'll out with his night-stick and whip your head to the red. Beat your head just as flat as a dime." She went off into a great blow of laughter.

"Oh, let's us don't talk about the law. Let's talk about us," Sweet Back persisted. "You going inside with me to holler 'Let one come flopping! One come grunting! Snatch one from de rear!'"

"Naw indeed!" the girl laughed harshly. "You skillets is trying to promote a meal on me. But it'll never happen, brother. You barking up the wrong tree. I wouldn't give you air if you was stopped up in a jug. I'm not putting out a thing. I'm just like the cemetery—I'm not putting out, I'm taking in! Dig?"

"I'll tell you like the farmer told the potato—plant you now and dig you later."

The girl made a movement to switch on off. Sweet Back had not dirtied a plate since the day before. He made a weak but desperate gesture.

"Trying to snatch my pocketbook, eh?" she blazed. Instead of running, she grabbed hold of Sweet Back's draping coat-tail and made a slashing gesture. "How much split you want back here? If your feets don't hurry up and take you 'way from here, you'll *ride* away. I'll spread my lungs all over New York and call the law. Go ahead, Bedbug! Touch me! And I'll holler like a pretty white woman!"

The boys were ready to flee, but she turned suddenly and rocked on off with her ear-rings snapping and her heels popping.

"My people! My people!" Sweet Back sighed.

"I know you feel chewed," Jelly said, in an effort to make it appear that he had had no part in the fiasco.

"Oh, let her go," Sweet Back said magnanimously. "When I see people without the periodical principles they's supposed to have, I just don't fool with 'em. What I want to steal her old pocketbook with all the money I got? I could buy a beat chick like her and give her away. I got money's mammy and Grandma change. One of my women, and not the best one I got neither, is buying me ten shag suits at one time."

He glanced sidewise at Jelly to see if he was convincing. But Jelly's thoughts were far away. He was remembering those full, hot meals he had left back in Alabama to seek wealth and splendor in Harlem without working. He had even forgotten to look cocky and rich.

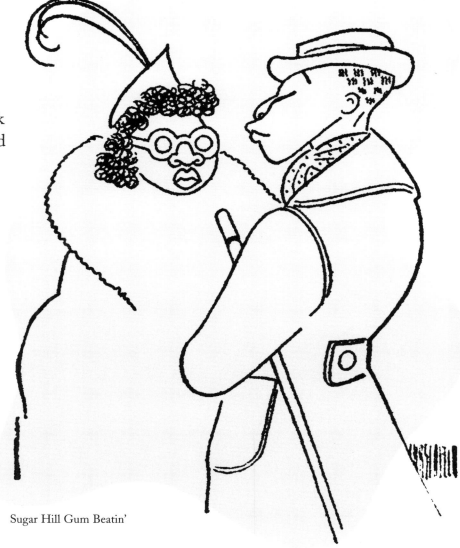

Sugar Hill Gum Beatin'

71

Glossary of Harlem Slang

Air out – leave, flee, stroll
Astorperious – haughty, biggity
Aunt Hagar – Negro race (also Aunt Hagar's chillun)
Bad hair – Negro type hair
Balling – having fun
Bam, and down in Bam – down South
Battle-hammed – badly formed about the hips
Beating up your gums – talking to no purpose
Beluthahatchie – next station beyond Hell
Big boy – stout fellow. But in the South, it means fool and is a prime insult.
Blowing your top –getting very angry; occasionally used to mean, "He's doing fine!"
Boogie-woogie – type of dancing and rhythm. For years, in the South, it meant secondary syphilis.
Brother-in-black – Negro
Bull-skating – bragging
Butt sprung – a suit or a skirt out of shape in the rear
Coal scuttle blonde – black woman
Cold – exceedingly well, etc., as in "He was cold on that trumpet!"
Collar a nod – sleep
Collar a hot – eat a meal

Delroy Lindo, *Joe Turner*, 1988

Color scale – high yaller, yaller, high brown, Vaseline brown, seal brown, low brown, dark black
Conk buster – cheap liquor; also an intellectual Negro
Cruising – parading down the Avenue. Variations: *oozing*, *percolating*, and *freewheeling*. The latter implies briskness.
Cut – doing something well
Dark black – a casually black person. Superlatives: *low black*, a blacker person; *lam black*, still blacker; and *damn black*, blackest man, of whom it is said: "Why lightning bugs follows him at 12 o'clock in the day, thinking it's midnight.
Dat thing – sex of either sex
Dat's your mammy – same as, "So is your old man."
Diddy-wah-diddy – (1) a far place, a measure of distance. (2) another suburb of Hell, built since way before Hell wasn't no bigger than Baltimore. The folks in Hell go there for a big time.
Dig – understand. "Dig me?" means "Do you get me? Do you collar the jive?"
Draped down – dressed in the height of Harlem fashion; also *togged down*.
Dumb to the fact – "You don't know what you're talking about."
Dusty butt – cheap prostitute
Eight-rock – very black person
Every postman on his beat – kinky hair
First thing smoking – a train. "I'm through with this town. I mean to grab the first thing smoking."
Frail eel – pretty girl
Free schools – a shortened expression of deprecation derived from "free schools and dumb Negroes," sometimes embellished with "free schools, pretty yellow teachers and dumb Negroes."
Function – a small, unventilated dance, full of people too casually bathed
Gator-faced – long, black face with big mouth
Getting on some stiff time – really doing well with your racket

Get you to go – power, physical or otherwise, to force the opponent to run

Ginny Gall – a suburb of Hell, a long way off

Git up off of me – quit talking about me, leave me alone

Go when the wagon comes – another way of saying, "You may be acting biggity now, but you'll cool down when enough power gets behind you."

Good hair – Caucasian-type hair

Granny Grunt – a mythical character to whom most questions may be referred

Ground rations – sex, also *under rations*

Gum beater – a blowhard, a braggart, idle talker in general

Gut-bucket – low dive, type of music, or expression from same

Gut-foot – bad case of fallen arches

Handkerchief-head – sycophant type of Negro; also an *Uncle Tom*

Hauling – fleeing on foot. "Man! He cold hauled it!"

I don't deal in coal – "I don't keep company with black women."

I'm cracking but I'm facking – "I'm wisecracking, but I'm telling the truth.

Inky dink – very black person

I shot him lightly and he died politely – "I completely outdid him."

Jar head – Negro man

Jelly – sex

Jig – Negro, a corrupted shortening of zigaboo

Jook – (pronounced like "took") a pleasure house, in the class of gut-bucket; now common all over the South

Jooking – (1) playing the piano, guitar, or any musical instrument in the manner of the Jooks (2) Dancing and "scrunching" ditto.

Juice – liquor

July jam – something very hot

Jump salty – get angry

Kitchen mechanic – a domestic

Knock yourself out – have a good time

Lightly, slightly and politely – doing things perfectly

Little sister – measure of hotness: "Hot as little sister!"

Liver-lip – pendulous, thick, purple lips

Jimmy Slyde,
Black and Blue,
1989

Made hair – hair that has been straightened

Mammy – a term of insult. Never used in any other way by Negroes.

Miss Anne – a white woman

Mister Charlie – a white man

Monkey chaser – a West Indian

Mug man – small-time thug or gangster

My people! My people! – Sad and satiric expression in the Negro language: sad when a Negro comments on the backwardness of some members of his race; at other times, used for satiric or comic effect

Naps – kinky hair

Nearer my God to Thee – good hair

Nothing to the bear but his curly hair — "I call your bluff," or "Don't be afraid of him; he won't fight."

Now you cookin' with gas – now you're talking, in the groove, etc.

Ofay – white person

Old cuffee – Negro (genuine African word for the same thing)

Palmer House – walking flat footed, as from fallen arches

Pancake – a humble type of Negro

Park ape – an ugly, underprivileged Negro

Peckerwood – poor and unloved class of Southern whites

Peeping through my likkers – carrying on even though drunk

Pe-ola – a very white Negro girl

Piano – spare ribs (white rib-bones suggest piano keys)

73

Georgia Burke, 1944

Pig meat – young girl

Pilch – house or apartment; residence

Pink toes – yellow girl

Playing the dozens – low-rating the ancestors of your opponent

Red neck – poor Southern white man

Reefer – marijuana cigarette, also a *drag*

Righteous mass or *grass* – good hair

Righteous rags – the components of a Harlem-style suit

Rug-cutter – originally a person frequenting house-rent parties, cutting up the rugs of the host with his feet; a person too cheap or poor to patronize regular dance halls; now means a good dancer.

Russian – a Southern Negro up north. "Rushed up here," hence a Russian.

Scrap iron – cheap liquor

Sell out – run in fear

Sender – he or she who can get you to go, i.e., has what it takes. Used often as a compliment: "He's a solid sender!"

Smoking, or *smoking over* – looking someone over

Solid – perfect

Sooner – anything cheap and mongrel, now applied to cheap clothes, or a shabby person.

Stanch, or *stanch out* – to begin, commence, step out

Stomp – low dance, but hot man!

Stormbuzzard – shiftless, homeless character

Stroll – doing something well

Sugar Hill – northwest corner of Harlem, near Washington Heights, site of newest apartment houses, mostly occupied by professional people. (The expression has been distorted in the South to mean a Negro red light district.)

The bear – confession of poverty

The big apple, also *the big red apple* – New York City

The man – the law, or powerful boss

Thousand on a plate – beans

Tight head – one with kinky hair

Trucking – (1) strolling (2) dance step from the strolling motif

V and X – five-and-ten cent store

West Hell – another suburb of Hell, worse than the original

What's on the rail for the lizard? – suggestion for moral turpitude

Whip it to the red – beat your head until it is bloody

Woofing – aimless talk, as a dog barks on a moonlight night

Young suit – ill fitting, too small. Observers pretend to believe you're breaking in your little brother's suit for him.

Your likker told you – misguided behavior

Zigaboo – a Negro

Zoot suit with the reet pleat – Harlem-style suit, padded shoulders, 43-inch trousers at the knee with cuff so small it needs a zipper to get into, high waistline, fancy lapels, bushels of buttons, etc.

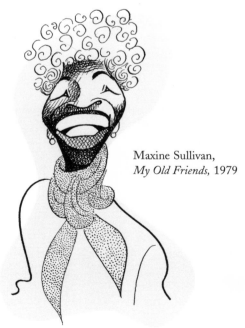

Maxine Sullivan, *My Old Friends*, 1979

Hirschfeld's Gallery of African American Legends

with
Commentary by
Hirschfeld
as told to
Glenn Young

HIRSCHFELD

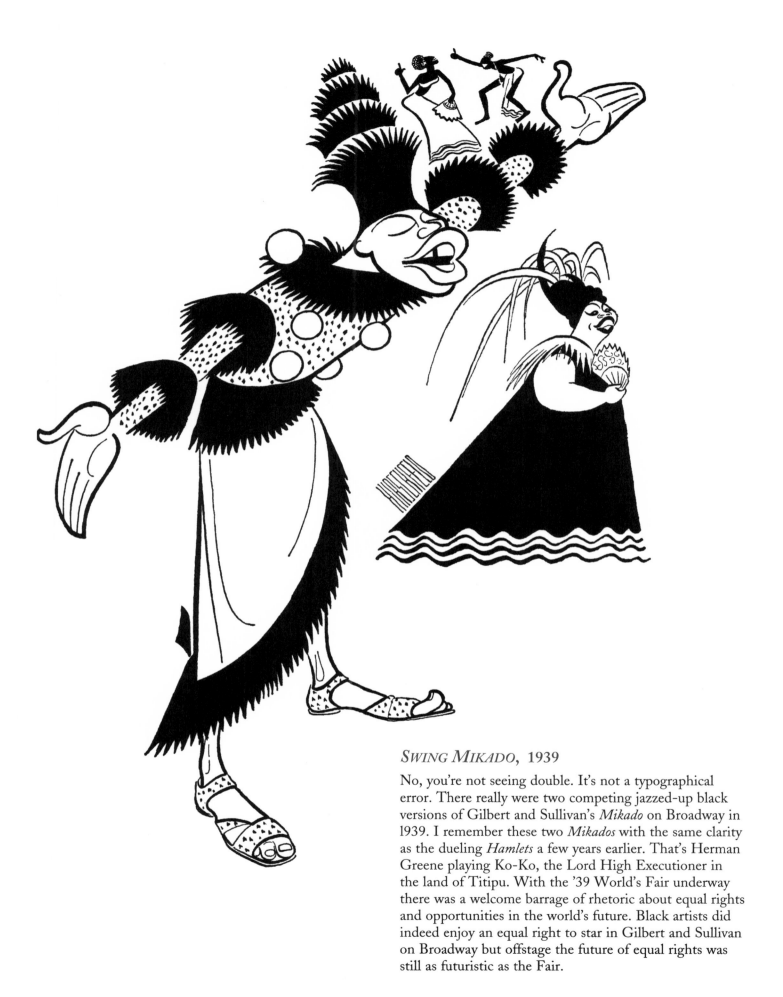

SWING MIKADO, 1939

No, you're not seeing double. It's not a typographical error. There really were two competing jazzed-up black versions of Gilbert and Sullivan's *Mikado* on Broadway in 1939. I remember these two *Mikados* with the same clarity as the dueling *Hamlets* a few years earlier. That's Herman Greene playing Ko-Ko, the Lord High Executioner in the land of Titipu. With the '39 World's Fair underway there was a welcome barrage of rhetoric about equal rights and opportunities in the world's future. Black artists did indeed enjoy an equal right to star in Gilbert and Sullivan on Broadway but offstage the future of equal rights was still as futuristic as the Fair.

BILL ROBINSON
Hot Mikado, 1939

Bill "Bojangles" Robinson could run backwards faster at age fifty than most track stars can run forward in their prime. I witnessed him tap dancing up and down those steps in *The Blackbirds of 1928*, and it might be that the steps were sweating, but Bill was as cool as a cucumber. It would be nigh impossible to overstate the charm Robinson exuded on stage. Here you see the Maestro strutting his Mikado in an electrifying production by Michael Todd. This was such a smash it transferred to the Hall of Music at the 1939 World's Fair where people lined up for hours to get in.

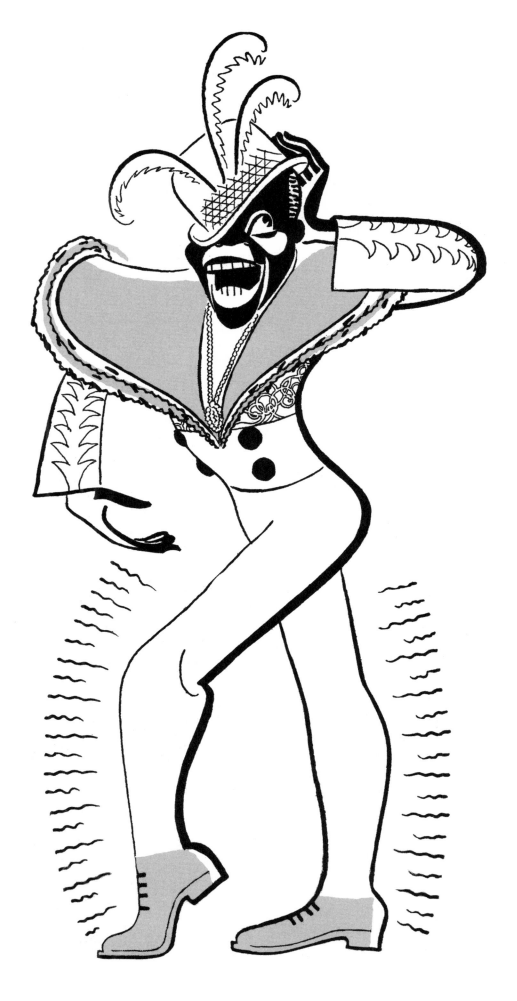

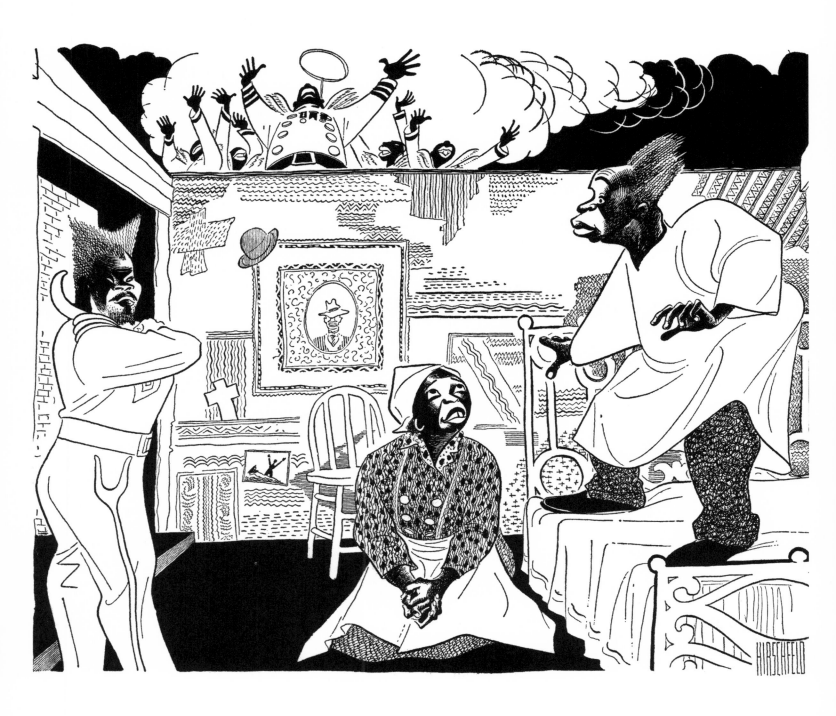

REX INGRAM AND ETHEL WATERS *Cabin in the Sky, 1940*

Rex Ingram is the menacing-looking Head Man. Ethel Waters pleads for Little Joe's soul. Todd
Duncan is the Lord's General coaching her from the rafters. The little guy responsible for all this
ruckus, Little Joe, is played by Dooley Wilson. Rex Ingram was a remarkable man of many parts.
He was the first black man to earn a Phi Beta Kappa key at Northwestern. He later would box
professionally in California. We would no doubt have seen much more of him from Hollywood but
for his steadfast refusal to accept stereotypical (that is, insulting) black parts.

CANADA LEE *Native Son, 1941*

Everyone knows Richard Wright's novel, *Native Son*. Or should. But I suspect not as many people remember Canada Lee, which is a great shame. His career was the victim of the HUAC fiasco which claimed so many great talents in this country. Canada actually went to grade school in Harlem, and later became an actor with the Harlem YMCA. His Harlem "Y" experience led directly to his Banquo in Orson Welles' famous WPA production of *Macbeth*. The whole searing production cried out for these charcoal shadows. I'm told this may not reproduce too well anymore but I hope you appreciate these shadows of shadows.

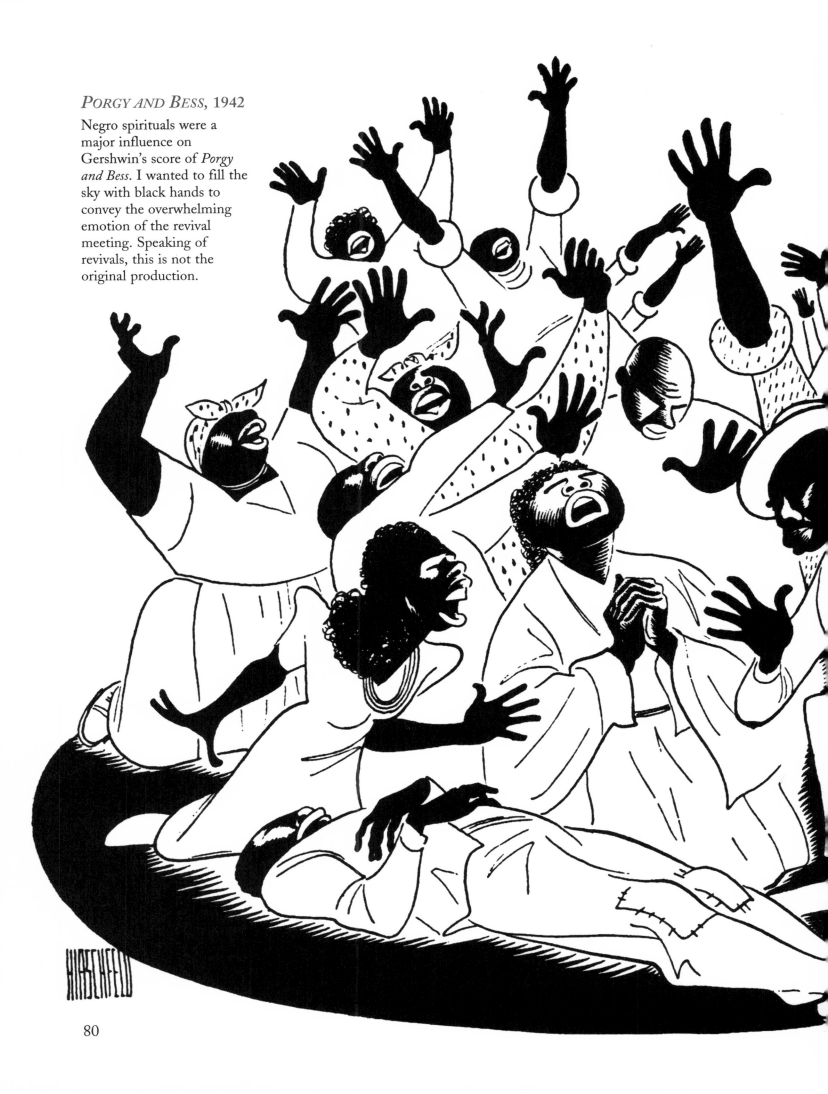

PORGY AND BESS, 1942

Negro spirituals were a major influence on Gershwin's score of *Porgy and Bess*. I wanted to fill the sky with black hands to convey the overwhelming emotion of the revival meeting. Speaking of revivals, this is not the original production.

80

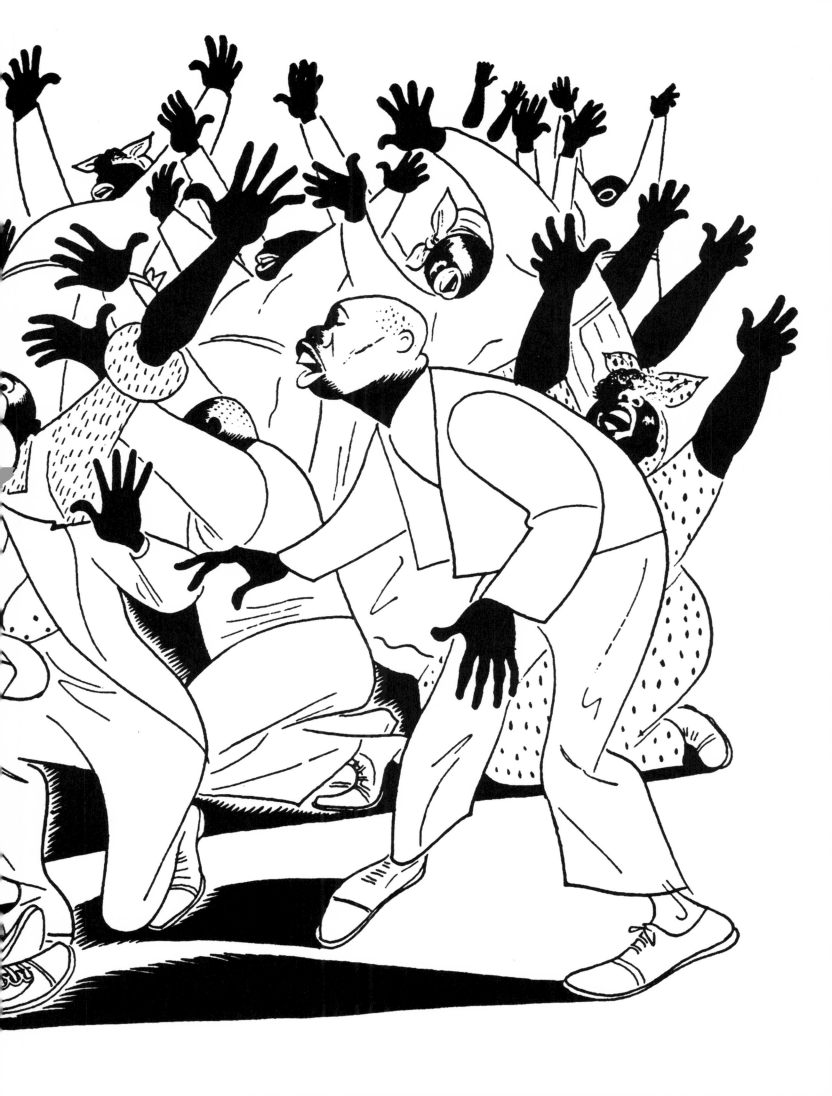

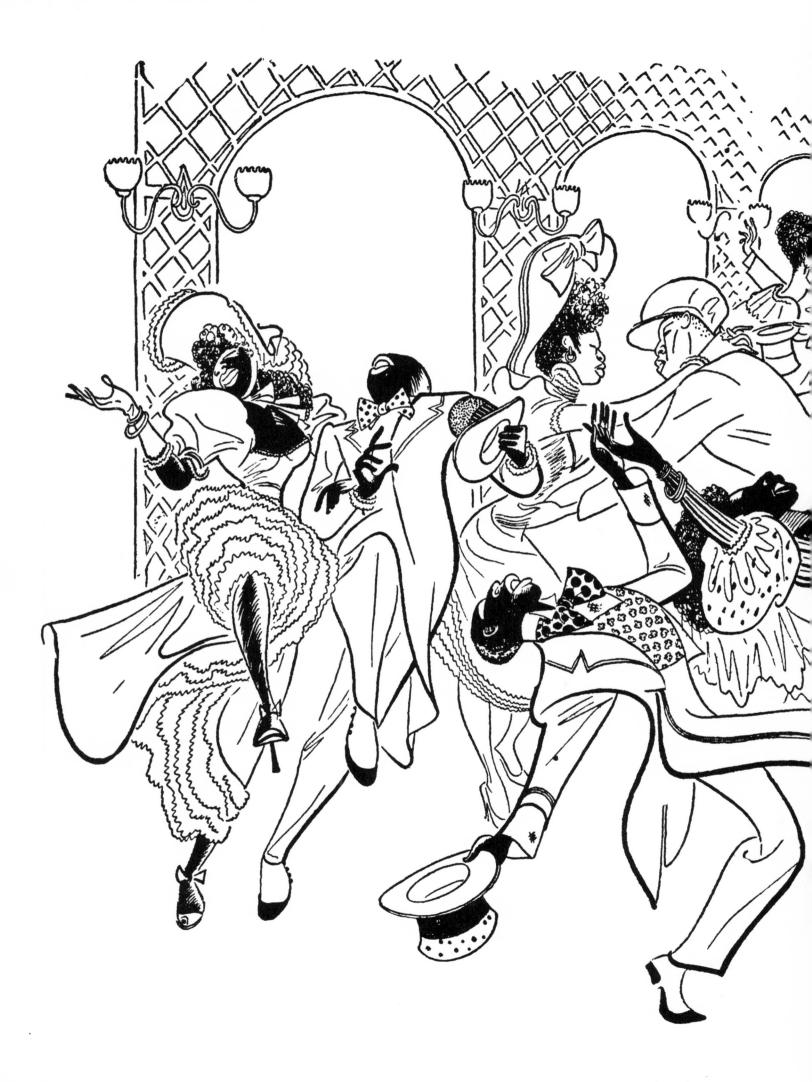

St. Louis Woman, 1946

What a score this show had! Lyrics by Johnny Mercer, music by Harold Arlen. Here, of course, is the spectacular "Cakewalk Your Lady" number, but the show was packed with sensational numbers. If I had paid the price of the ticket, it would have been worth it, just to hear "Come Rain or Come Shine." This is also one of those shows famous for who wasn't in it. Lena Horne turned it down.

DUKE ELLINGTON, 1946

Born in Washington, DC, came
to New York City when he was
about 24, Duke Ellington was
Harlem royalty virtually from
the start. He lived royally too,
on Harlem's Sugar Hill. He was
also quite a regal dresser. I
caught him here in his dressed
down rehearsal rags. He and his
orchestra were sophistication
incarnate. What would
American music of the past
century have been without him?

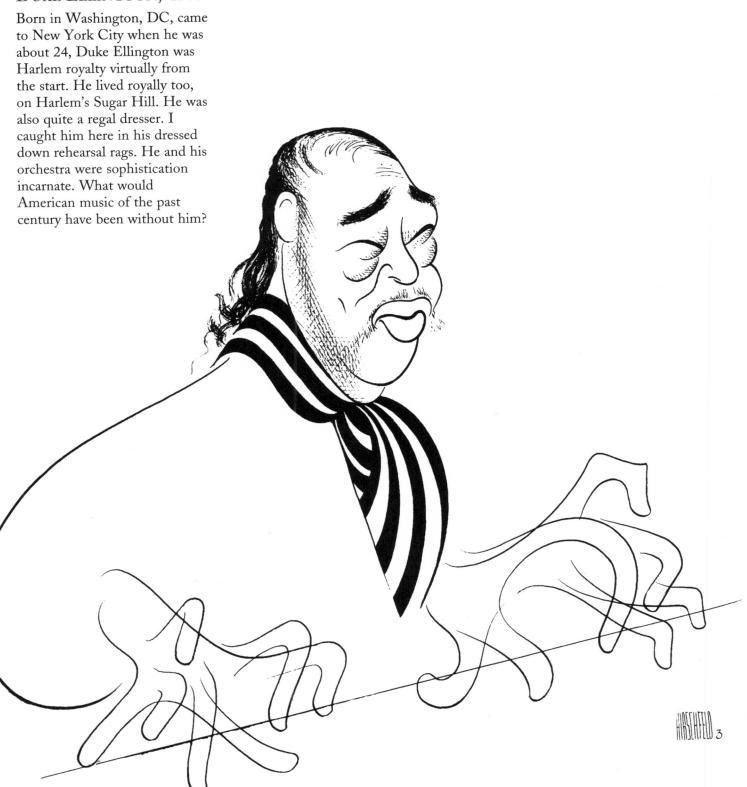

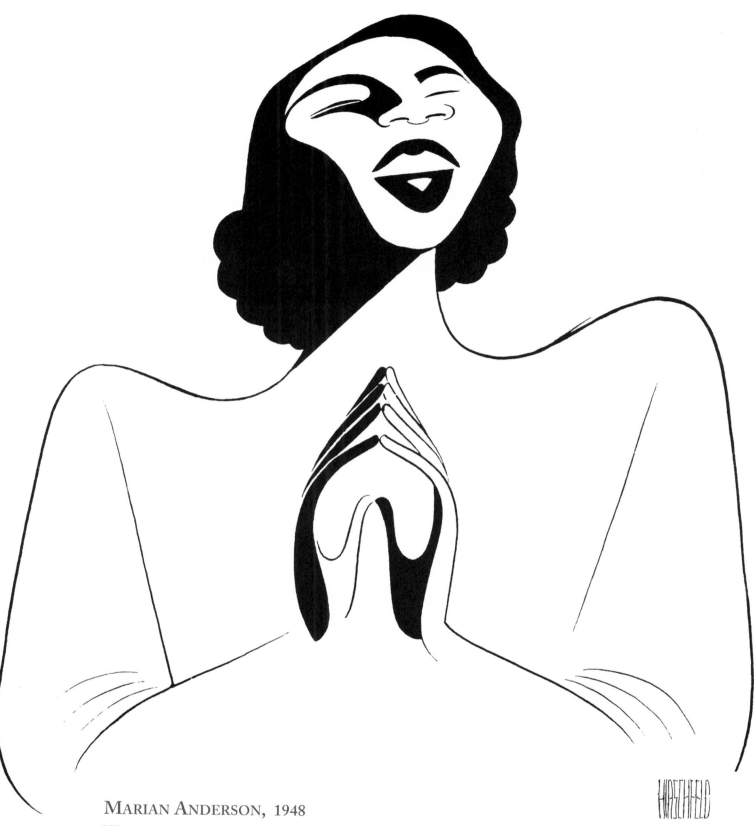

MARIAN ANDERSON, 1948

Who can ever forget that this great American was refused the stage by the Daughters of the American Revolution (the DAR) because she was black? Who can ever forget the concert Eleanor Roosevelt organized in protest in front of the Lincoln Memorial on Easter Morning? And who will ever forget hearing Marian Anderson sing "America"? Who can ever forget that Marian Anderson refused from that day hence to sing in a segregated place? Who can ever forget that she would become the first African American to perform a major role at the Metropolitan Opera? Who can ever forget . . . Marian Anderson?

LESLIE BANKS, JULIAN MAYFIELD, TODD DUNCAN *Lost in the Stars, 1949*

Here's an adaptation of another literary classic, Alan Paton's *Cry, the Beloved Country*. This production must have been responsible for at least another print run. Leslie Banks is leaning on the Johannesburg skyscrapers, Julian Mayfield behind bars and below him, lamenting the whole tragic goings-on, Todd Duncan. This was also the last Broadway score by Kurt Weill with book and lyrics by Maxwell Anderson.

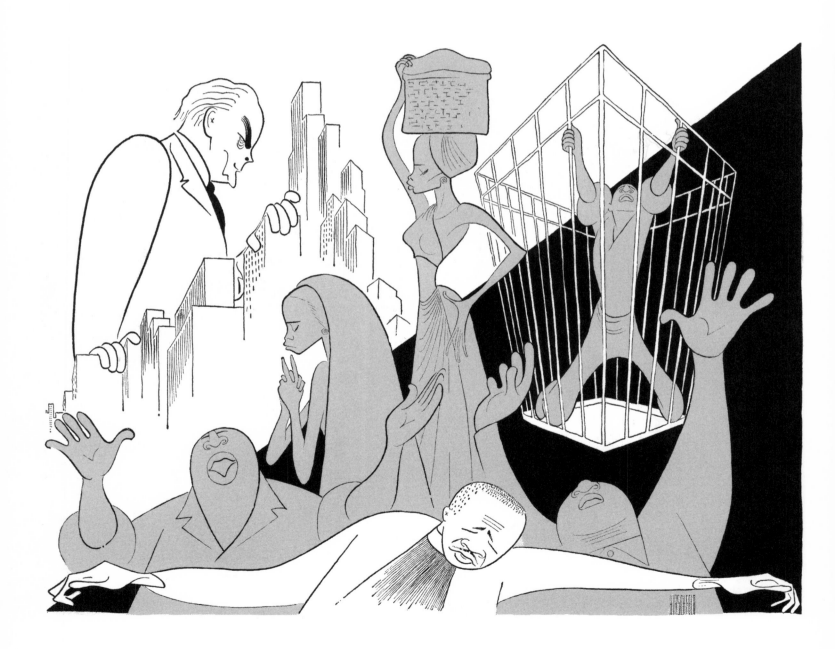

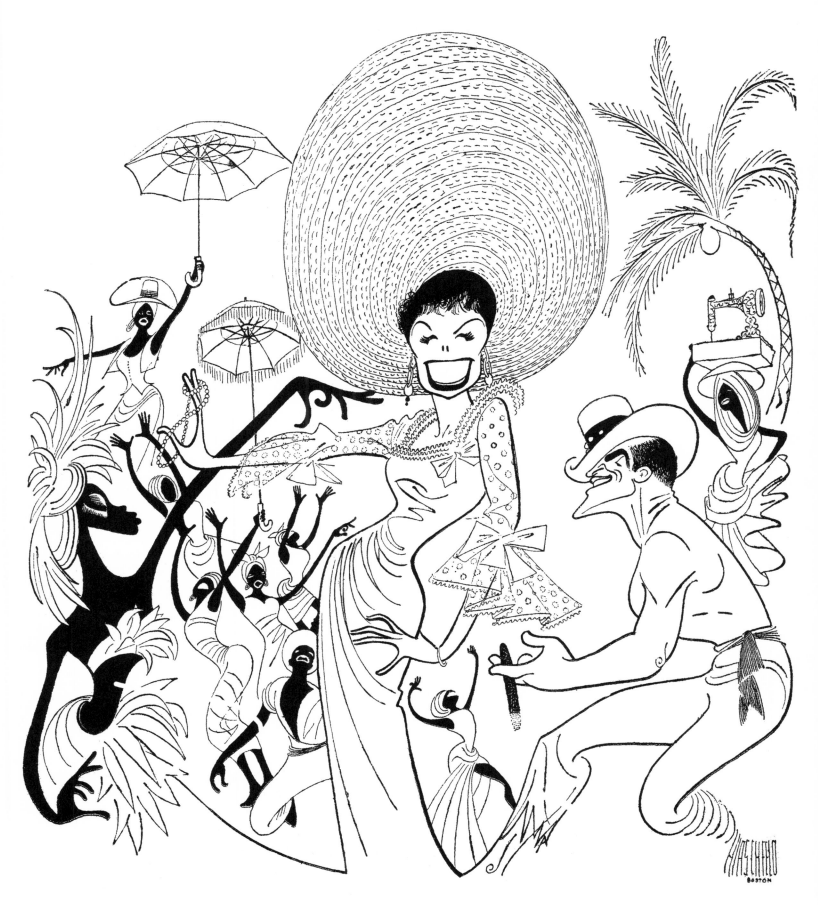

LENA HORNE AND RICARDO MONTALBAN *Jamaica, 1957*

Lena Horne is wearing a hat almost as big as her talent. Ricardo Montalban, playing a Caribbean local, is trying to talk Miss Horne out of defecting for the bright lights of Manhattan. And with the marvelous energy of the performers surrounding her you can't help but feel the tough decision facing her.

HARRY BELAFONTE *Take a Giant Step, 1959*

Most people would bet Harry Belafonte was from someplace in the Caribbean. Save your money. He was actually born in Harlem. He grew up in Jamaica and only returned during World War II. He was kicking around until he saw a stage show at the American Negro Theatre. That show was his giant step. Here, he's playing a troubled teen with everybody giving him a hard time. I sympathized then, and I sympathize now.

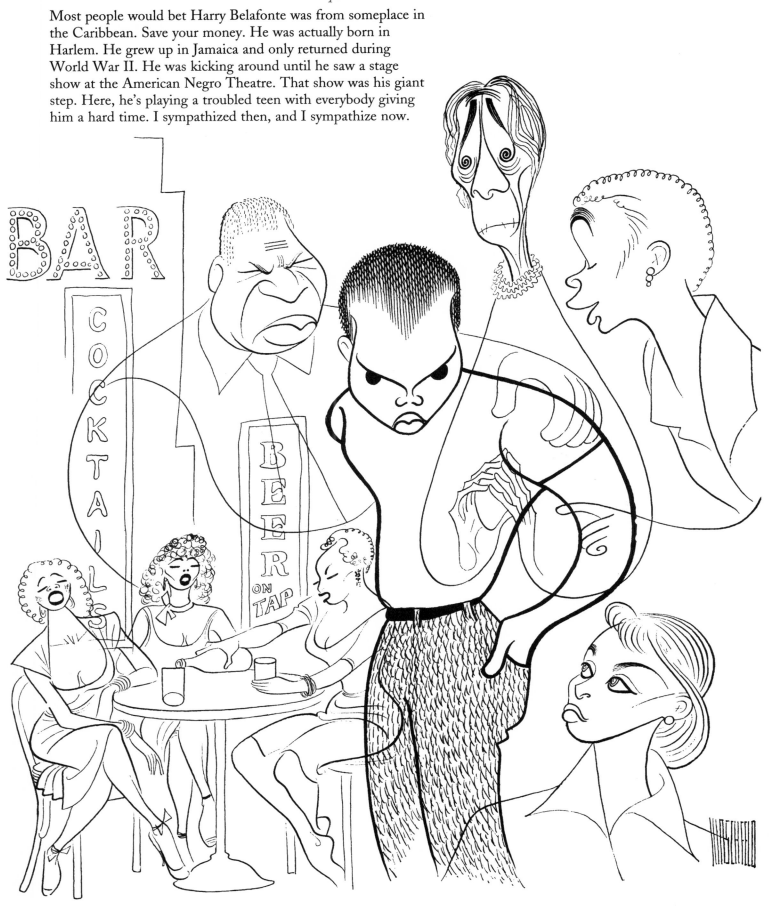

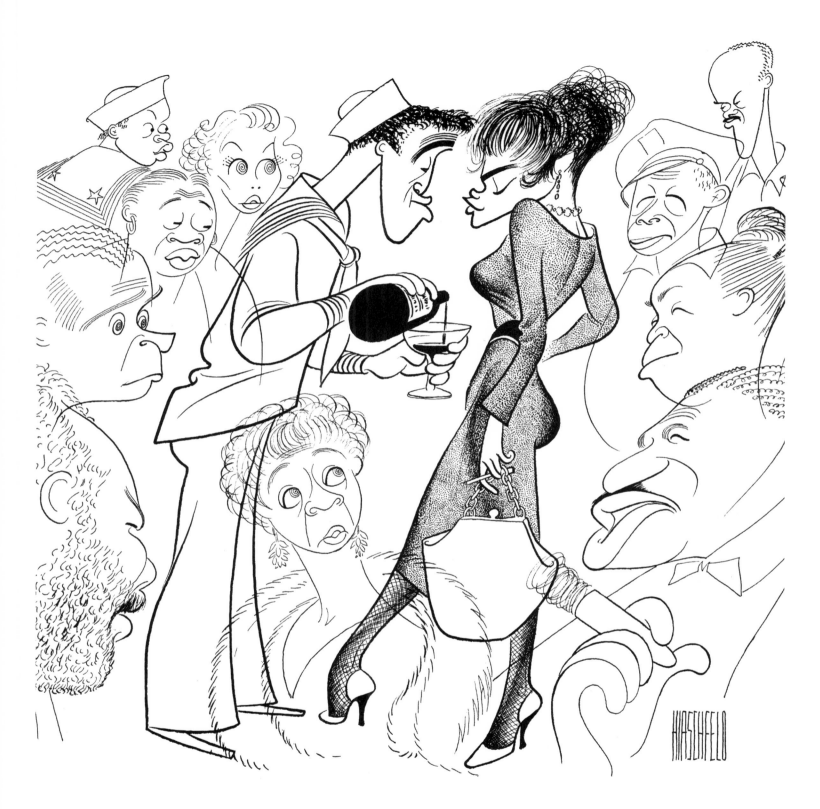

EARTHA KITT AND SAMMY DAVIS, JR. *Anna Lucasta, 1958*

In 1949, Hollywood made a version of Philip Yordan's play (which had an all-black original cast) with Paulette Goddard and Oskar Homolka! That tells you all you need ever know about the troubles African Americans were facing in Hollywood. Finally in 1958, this classic remake restored some reality to the picture's palette with Sammy Davis Jr. and Eartha Kitt in the leads.

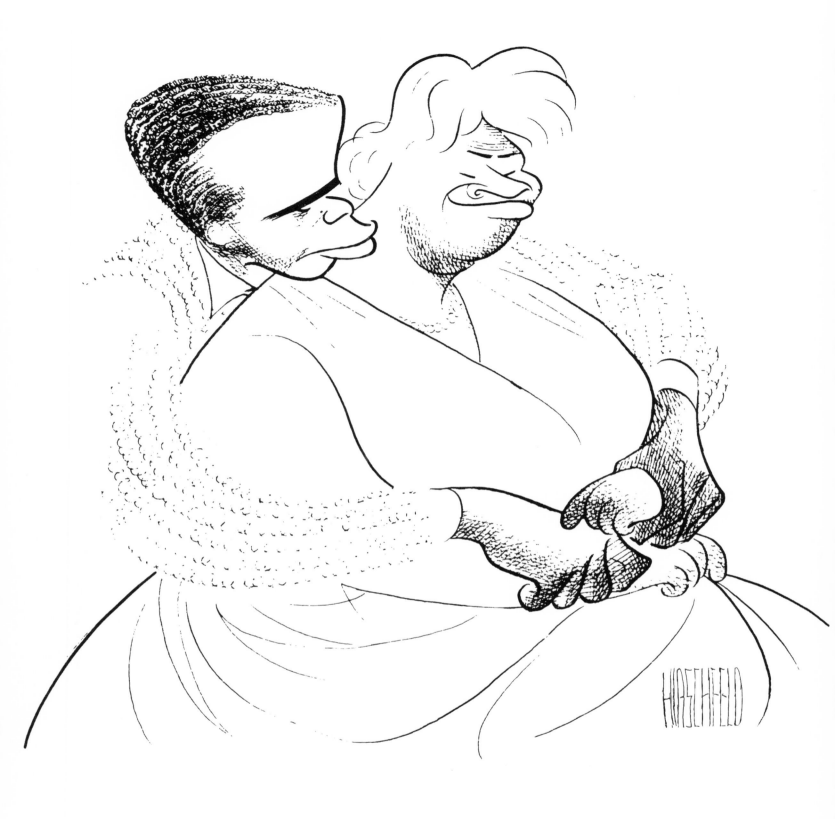

SIDNEY POITIER AND CLAUDIA McNEIL *Raisin in the Sun, 1959*

Orson Welles' *Macbeth* gave incontrovertible proof that black actors could triumph in the classics. *Raisin* showed the world that the lives of an ordinary Black American family could rivet the attention of the whole world. The play and later the film launched Sidney Poitier's career, but many consider Claudia MacNeil's portrayal of Mama, the rock solid matriarch, as the real heart of the drama. Is Sidney hugging her here or trying to keep her from upstaging him?

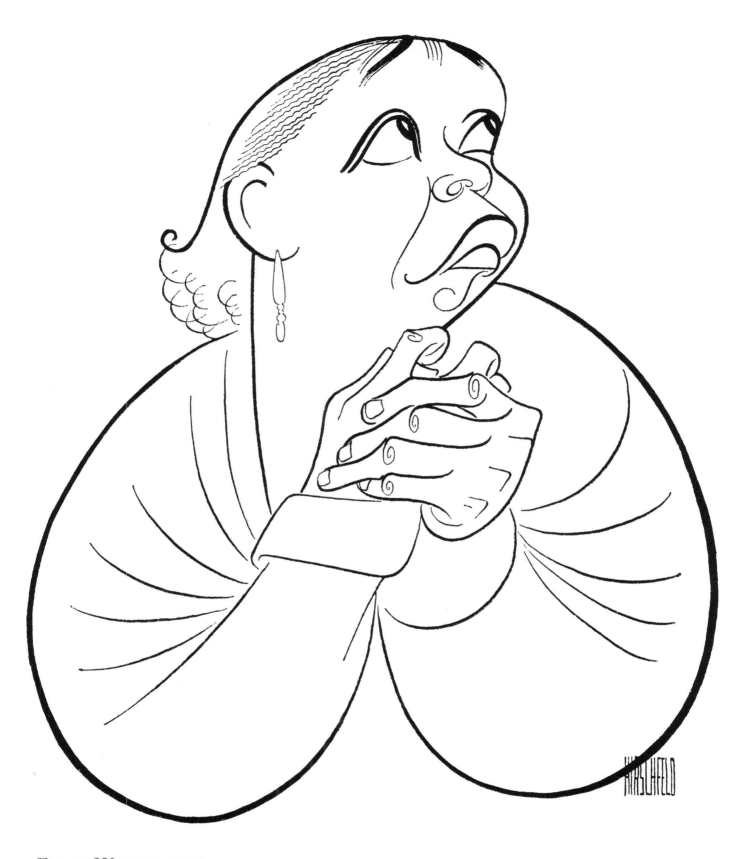

ETHEL WATERS, 1953

As much as I specialize in acrobatics, one needs to know when to get off the trapeze. Some of our greatest actors are at their most dynamic when they are completely still. Ethel Waters needs only to look at you for you to feel like you've just had a hot cocoa laced with Irish whiskey. Her jolt is quiet and I hope you may find her hands as arresting as her eyes.

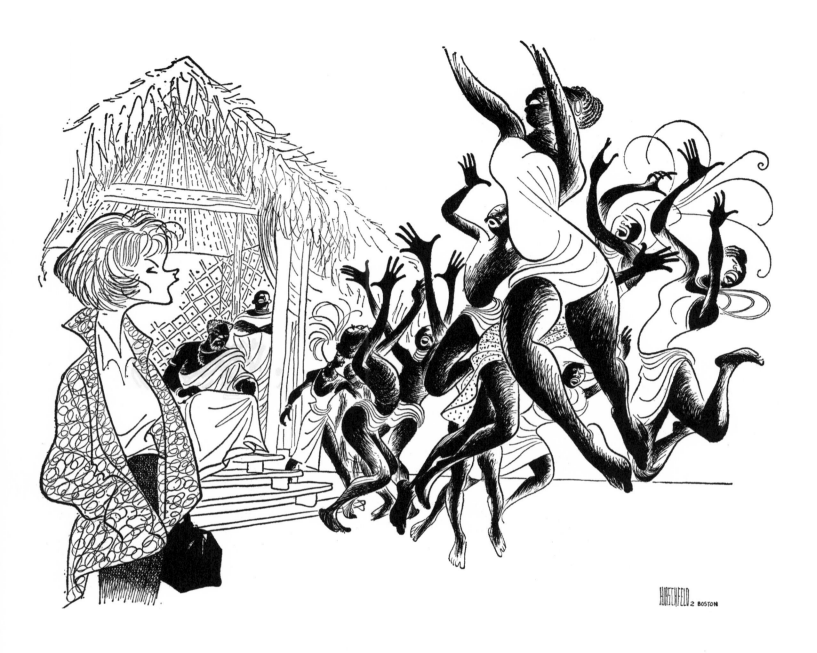

SALLY ANN HOWES AND REX INGRAM *Kwamina, 1961*

Before you say this sounds like your basic *Guess Who's Coming to Dinner* with skimpier costumes, you might recall that the movie doesn't come along for another half dozen years. Sally Ann Howes plays an African-born gal in love with the son of the chieftain. How wonderful to see Rex Ingram where he belongs on a throne looking extremely regal. The pretext for the marvelous dancing and singing was the country's independence celebration. And what country wouldn't celebrate its independence if their dances could be choreographed by Agnes de Mille?

SIDNEY POITIER *Lilies of the Field, 1963*

Sidney Poitier was knocking down racial barriers in the Sixties like a one-man wrecking crew. *Lilies of the Field* is a swell movie to boot. Poitier plays an out-of-work contractor traveling west who gets roped into single-handedly building a new church for a group of nuns—for free. The movie appeared right in the teeth of the Civil Rights movement. Can't you just hear some of our less enlightened audience members consoling themselves: "Well, he's black, true, but they're just nuns. What can happen?" Well, a helluva lot could, and did.

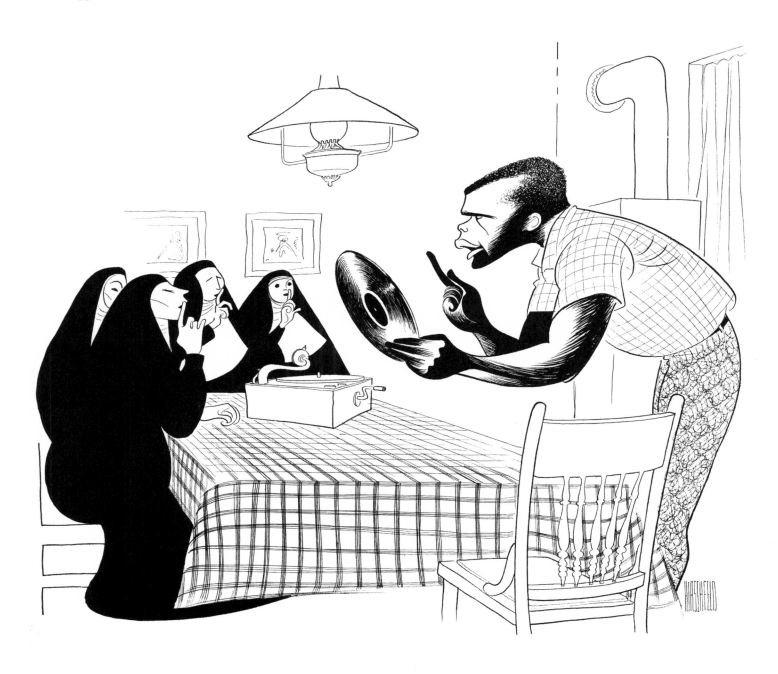

LOUIS GOSSETT AND MENASHA SKULNIK

The Zulu and the Zayda, 1965

Can I get a show of hands here of how many people remember the musical *The Zulu and the Zayda*? Well, you missed the last Broadway score by Harold Rome and the beguiling duo of Skulnik and Gossett. A more unlikely pair you couldn't imagine—naturally that was the point. Skulnik was a grand old figure of the Yiddish theatre. And Gossett (no Jr. appended at that point) had been coming on strong since his appearance in *Take a Giant Step* when he was but seventeen. He'd sung in cafés, played for the Knicks a while, and became the bona fide star we know now when he starred in *An Officer and a Gentleman* in 1982. Skulnik, by contrast, as far as I know, never played for the Knicks.

SAMMY DAVIS, JR. AND PAULA WAYNE
Golden Boy, 1964

People say vaudeville died.It didn't die. It changed its name to Sammy Davis, Jr. He was like another genius black performer, Louis Armstrong. Sammy and Louis were the men on the front line. They're the ones who through their talent and sweat made the world swing about. Sammy could command a stage, on Broadway, or anywhere, like no one else. Here he is with Paula Wayne in the mid-Sixties hit, *Golden Boy.*

DIANA SANDS *St. Joan, 1967*

Diana Sands was a very powerful and clever Joan, but she was nearly burned at the stake herself a few years earlier over a controversy about another play. She was cast opposite Alan Alda in *Owl and the Pussycat* in a part clearly written for a white actress. Not a syllable was adjusted to reflect Sands' race. The theatrical "purists" sputtered with disbelief. How did Sands handle it? She played it straight, straight into the history books. Sands was one of the pioneers who broke down color-based casting in America. Like so many people on the vanguard, Diana died early—at the age of thirty-nine.

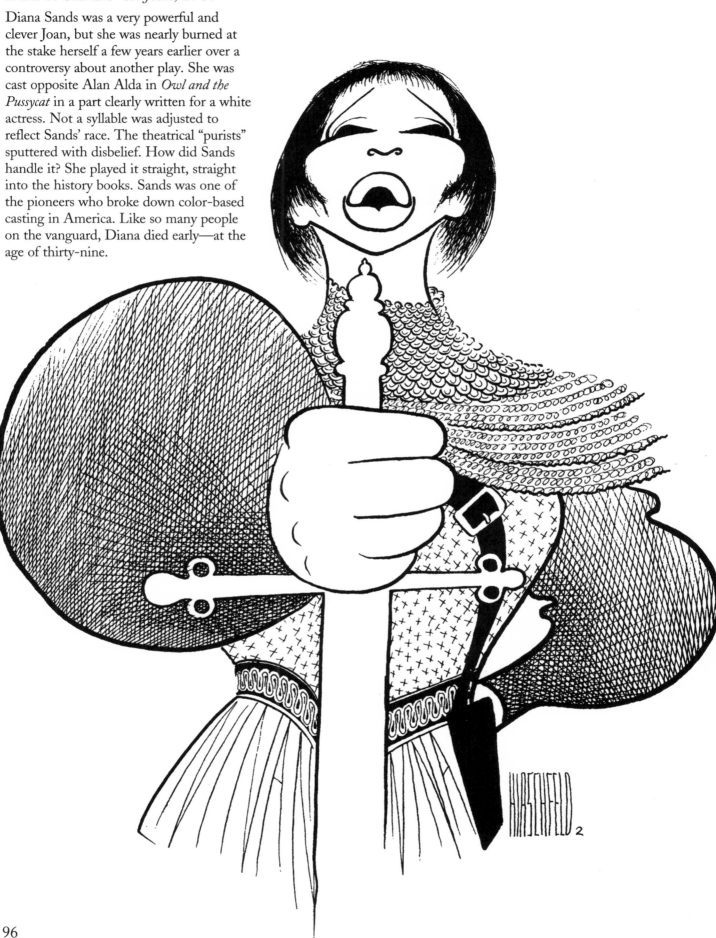

96

DUKE ELLINGTON

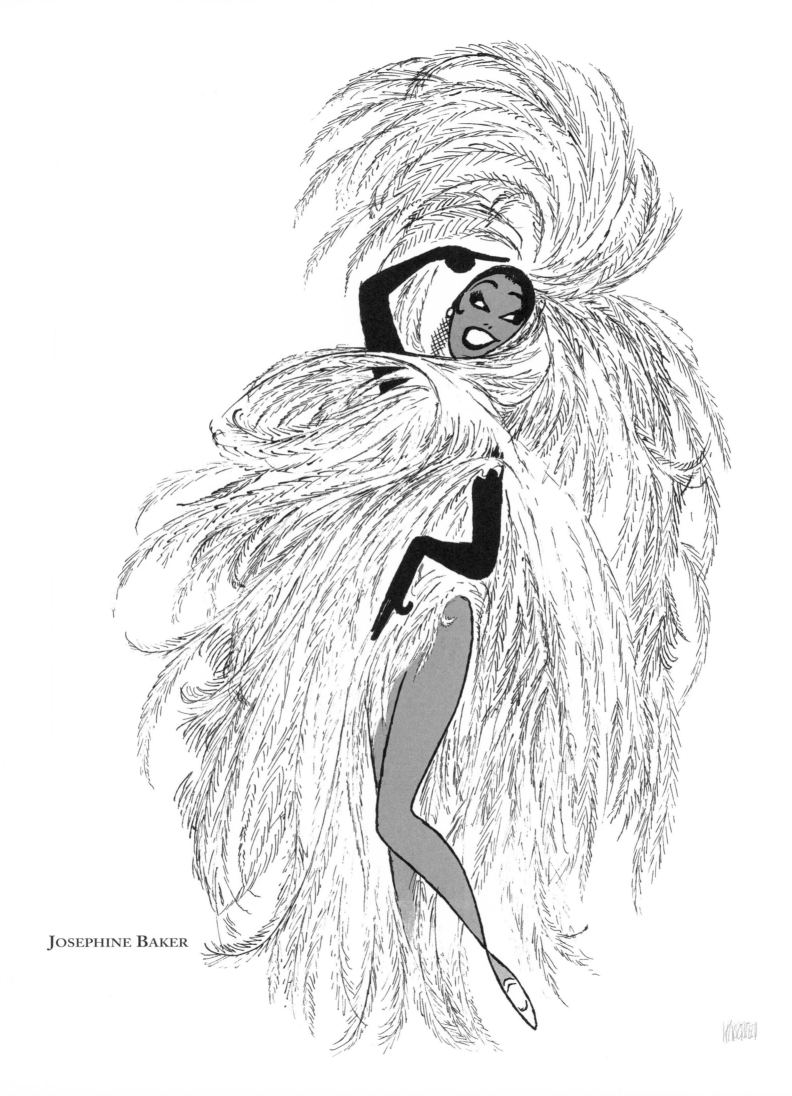

JOSEPHINE BAKER

CAKEWALK

CHARLESTON

KATHERINE DUNHAM

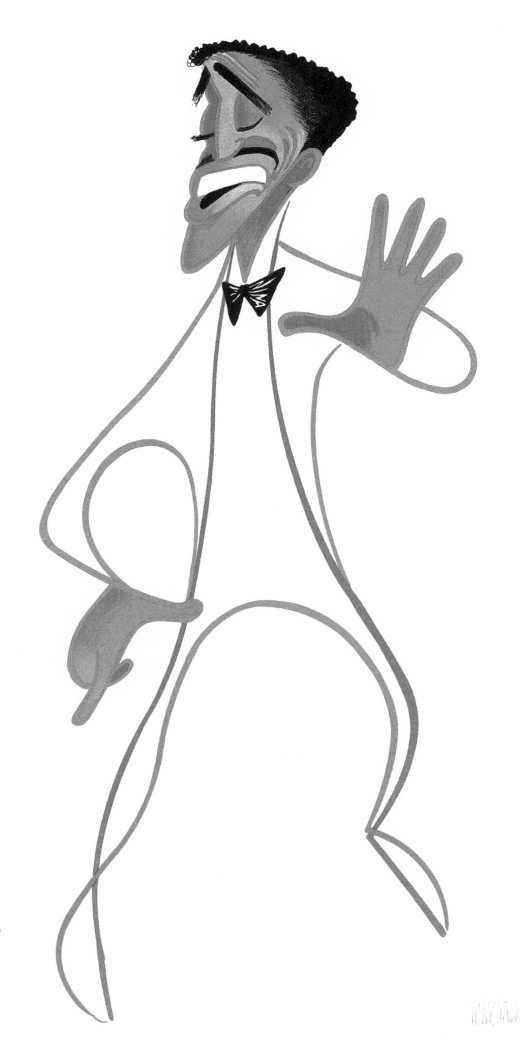

SAMMY DAVIS, JR.

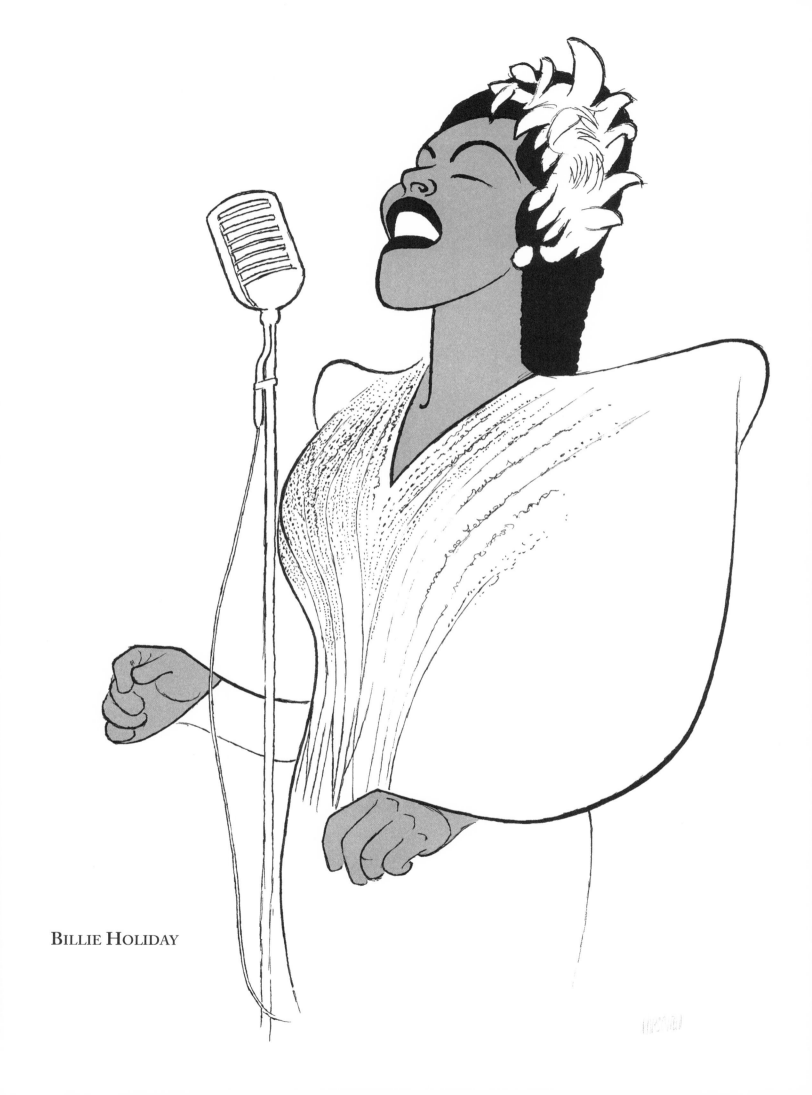

BILLIE HOLIDAY

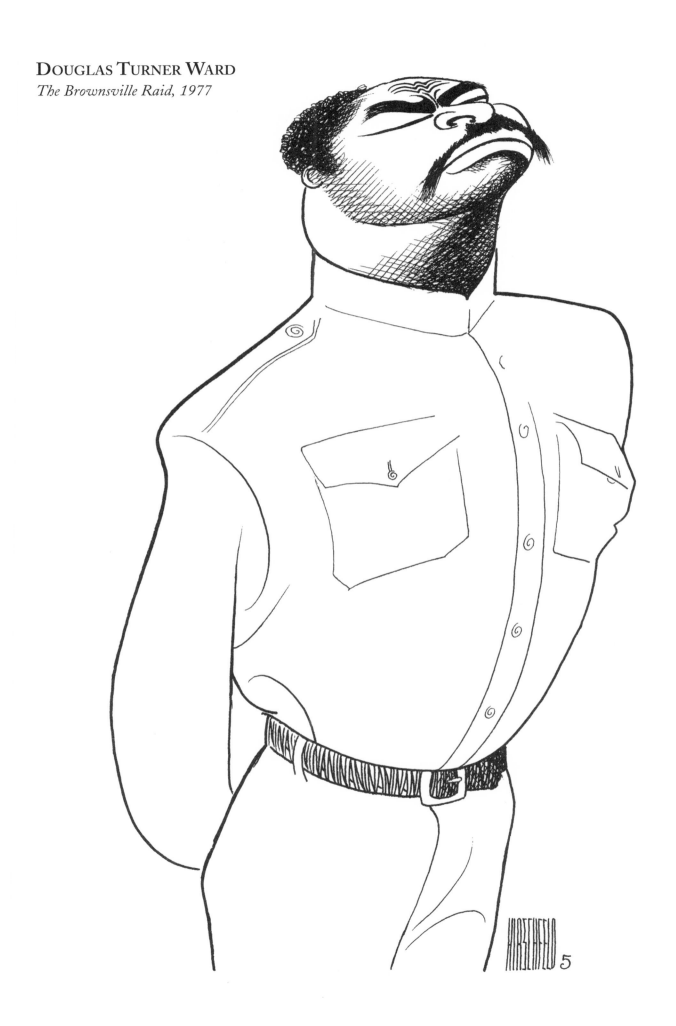

ARTHUR MITCHELL AND SUZANNE FARRELL *On Your Toes, 1968*

In 1936 Rodgers and Hart wrote the musical *On Your Toes* with a number in it called "Slaughter On Tenth Avenue" choreographed by George Balanchine. Thirty-two years later, the New York City Ballet staged *Slaughter* as a ballet, starring Suzanne Farrell (as the Stripper) and Arthur Mitchell (as the Hoofer). Call it whatever you like, in my book, I call it superlative theatre. Arthur Mitchell has gone on to create a world-class dance company whose work never fails to inspire me.

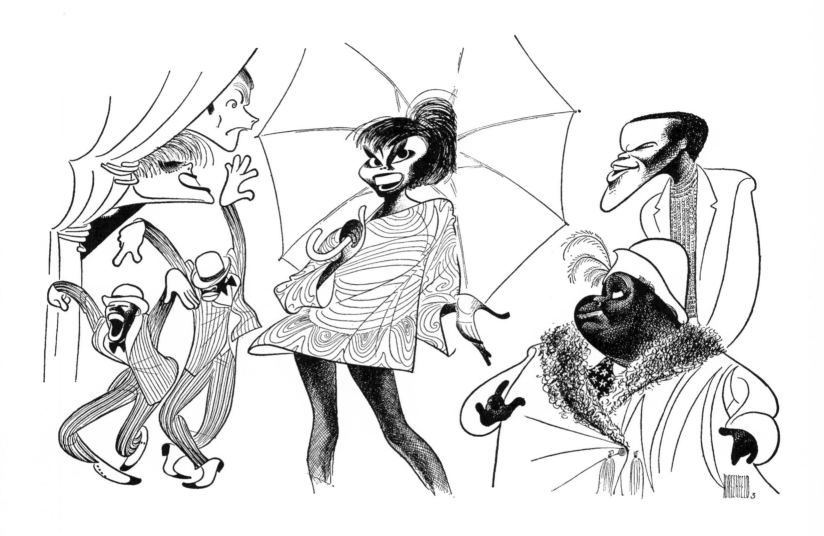

LESLIE UGGAMS *Hallelujah, Baby!, 1968*

The play's action spans the Twentieth Century (well, so do I) showing the progession, or lack thereof, in the struggle for equality. Here Leslie Uggams gives us a very modern (for 1967, that is) character named Georgina. I'm not sure what Georgina's tie-dyed miniskirt had to do with Civil Rights, but on Ms. Uggams, it looked absolutely liberating. The lyrics by Comden and Green and the music by Jule Styne are as much a cause to celebrate today as when they won the Tony in 1968. A sterling cast: Allen Case, Barbara Sharma, Winston de Witt Hemsley, Alan Weeks, Miss Uggams, Robert Hooks, and Lillian Hayman.

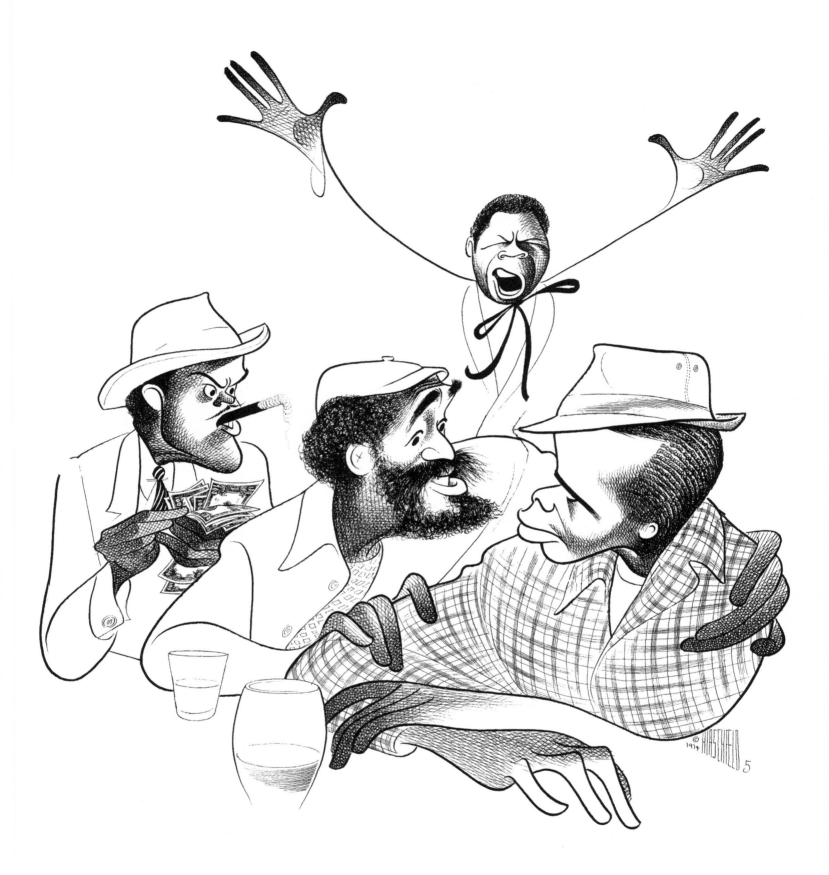

BELAFONTE, COSBY, POITIER AND FLIP WILSON *Uptown Saturday Night, 1974*

You just know Sidney Poitier spent the Sixties praying that one day if he played his cards right he could play a thug, anything other than an upstanding noble figure. He and Harry Belafonte finally got their chance to play a couple of regular guys in *Uptown Saturday Night*. Sidney was also the director of the picture, which might have helped landing the part.

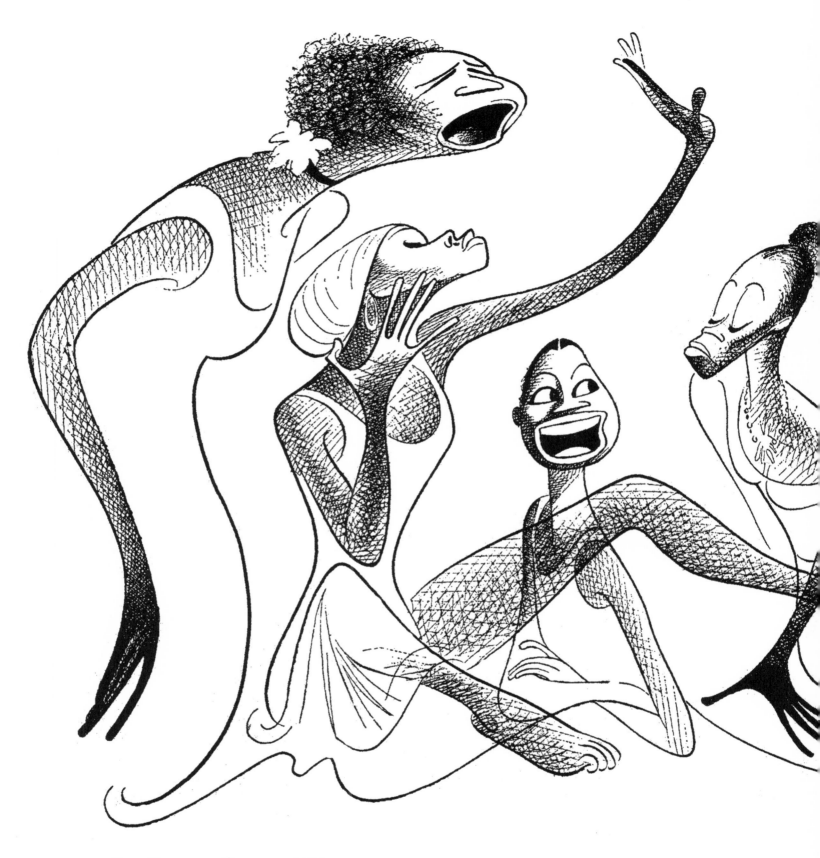

FOR COLORED GIRLS..., 1976

Choreopoems were a new experience, even for me, but Ntozake Shange's *For Colored Girls Who Have Considered Suicide/When the Rainbow is Enuf* was an eye and ear opener in 1976. Even with a title longer than many first acts, it left a deep impression whose source came from the interplay of sound and emotion. A truly super cast took the show from Joe Papp's Public Theater to Broadway: Trazana Beverly, Paula Moss, Janet League, Aku Kadogo, Rise Collins, Laurie Carlos and the multi-talented Ms. Shange herself.

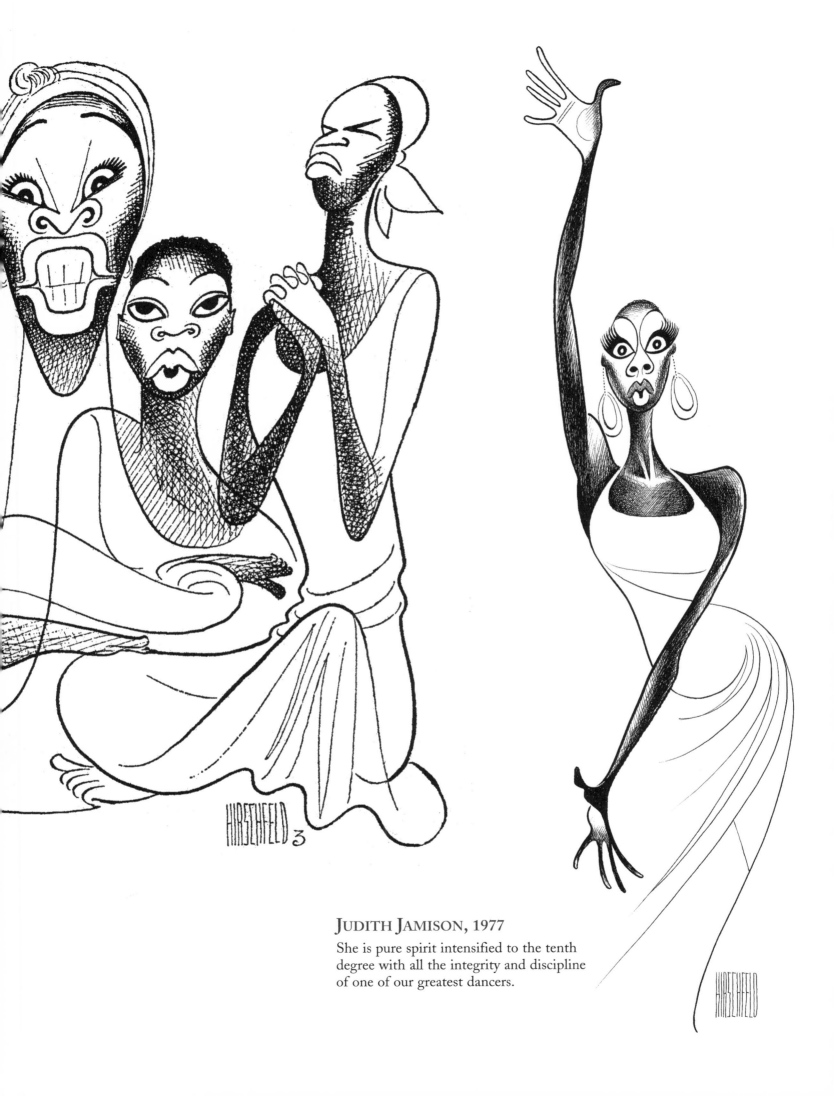

JUDITH JAMISON, 1977

She is pure spirit intensified to the tenth degree with all the integrity and discipline of one of our greatest dancers.

EUBIE BLAKE, 1978

Eubie Blake could still tickle those ivories in 1978 when he was 95—a youngster by my standards. Five years after this drawing, in his centennial year, he performed on live TV celebrating his birthday. He died six days later. What a way to go! The composer of "I'm Just Wild About Harry," Eubie got his start as a ragtime pianist and played a role in the very first black musical on Broadway, *Shuffle Along*.

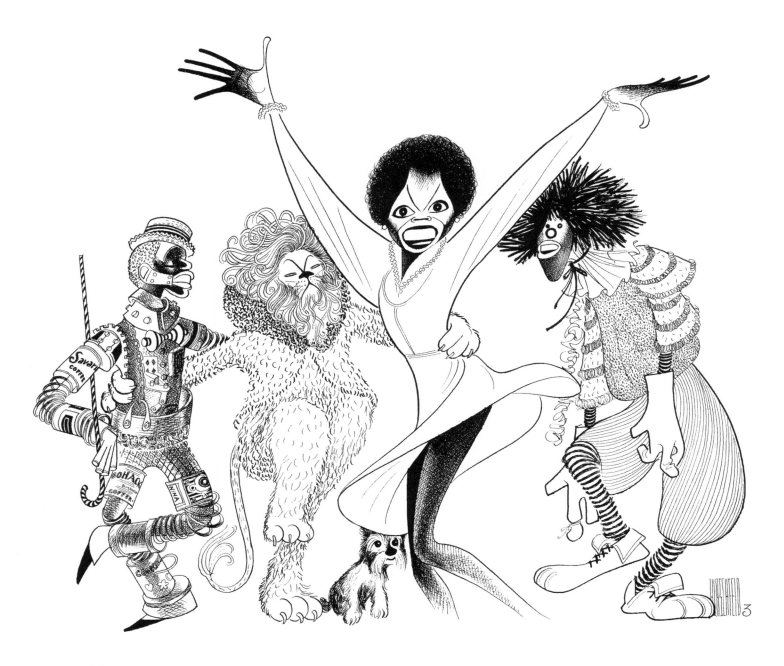

THE WIZ, 1978

The Wiz hit Broadway in 1975 with the future Mrs. Huxtable (Phylicia Rashad) as a Munchkin. Producers are always looking for some new way to recast a dime, but *The Wiz*, directed by one of our greatest theatrical Merlins, Geoffrey Holder, was a newly minted Oz and genuinely original all over again. You'd think when it was melted down and poured out into movie canisters again, it would have been ten times more original. But Hollywood didn't listen to the Tin Man, and, alas, *The Wiz*, while it coruscated with great Black talent, had lost its heart. Diana Ross gave a wonderful performance. The cast could have filled an Oscar telecast: Michael Jackson as the Scarecrow, Nipsey Russell as the Tin Man, Lena Horne as Glinda, and Richard Pryor as The Wiz. And the costumes by Tony Walton were out of this world.

JAMES EARL JONES *Fences, 1987*

James Earl Jones is one of the men in America whose story must inspire all who hear it. Imagine, he was born with an unshakeable stutter that effectively rendered him mute for much of his childhood. Here he is today with one of the most recognizable voices in the world. How'd he do it? He faced his demons. He faced an audience night after night. And aren't we blessed to hear him! I've drawn him here in August Wilson's Pulitzer Prize winning play, *Fences*.

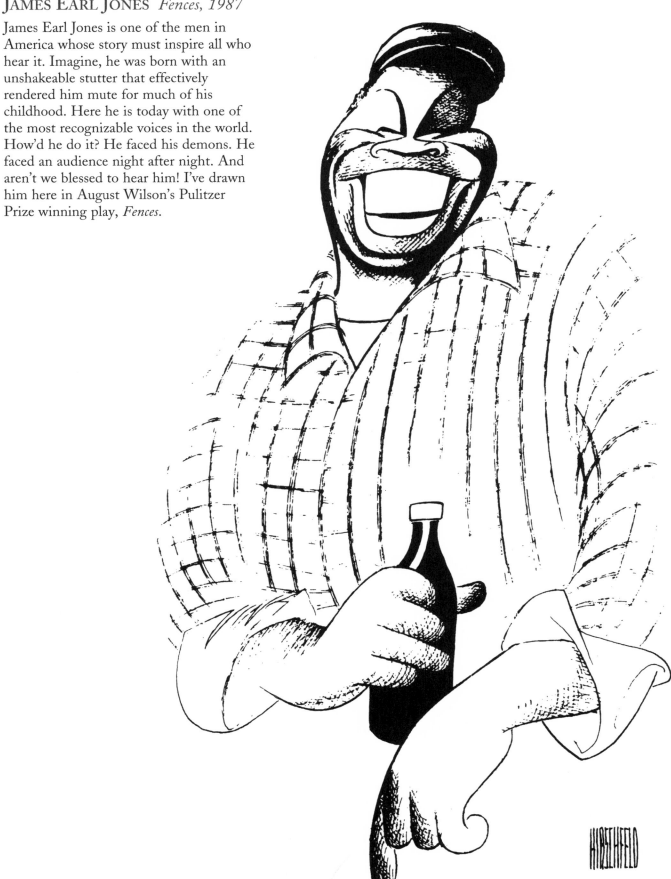

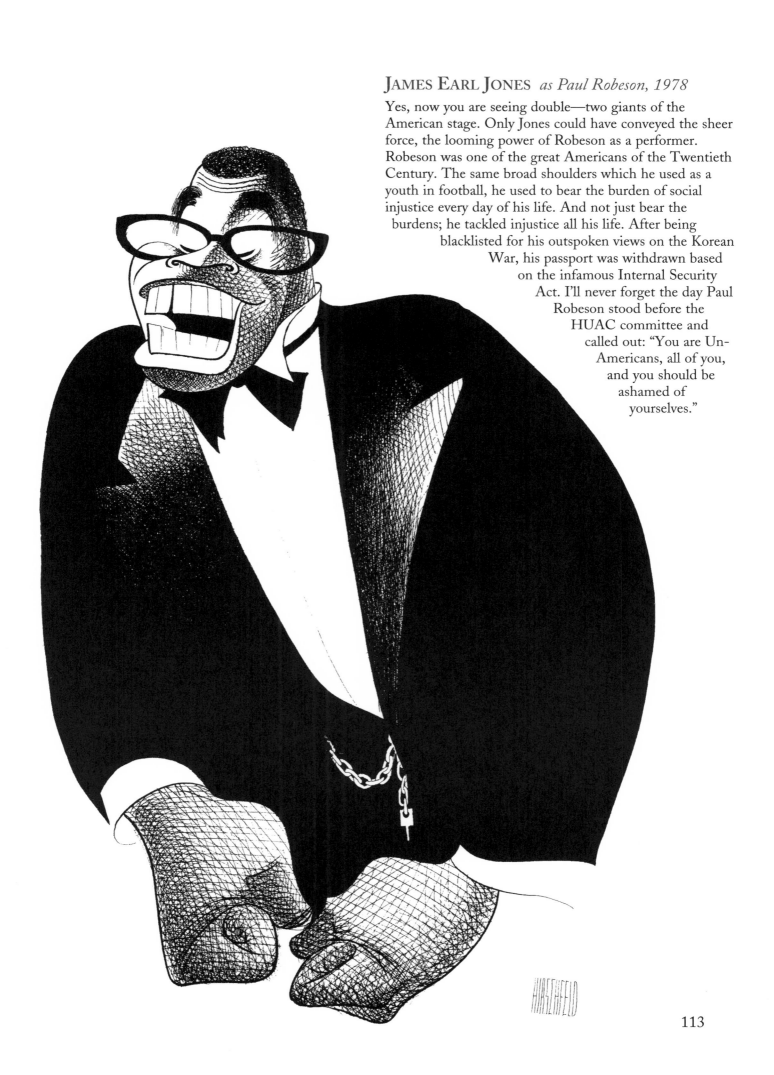

JAMES EARL JONES *as Paul Robeson, 1978*

Yes, now you are seeing double—two giants of the American stage. Only Jones could have conveyed the sheer force, the looming power of Robeson as a performer. Robeson was one of the great Americans of the Twentieth Century. The same broad shoulders which he used as a youth in football, he used to bear the burden of social injustice every day of his life. And not just bear the burdens; he tackled injustice all his life. After being blacklisted for his outspoken views on the Korean War, his passport was withdrawn based on the infamous Internal Security Act. I'll never forget the day Paul Robeson stood before the HUAC committee and called out: "You are Un-Americans, all of you, and you should be ashamed of yourselves."

THE COSBY SHOW, 1985

The show may have been *Ozzie and Harriet* with an African-American twist, but it still shattered many important taboos on the small tube. And a very talented family too: Bill Cosby, Phylicia Ayers-Allen, Malcolm Jamal-Warner, Lisa Bonet, Tempest Bledsoe, Sabrina LeBeauf, and Keshia Knight Pulliam. Cosby had been a superstar for decades before he became a TV doctor, but taking a black sitcom to number one in the ratings had a seismic cultural impact. American television would never be the same. Though I still think his early records were funnier.

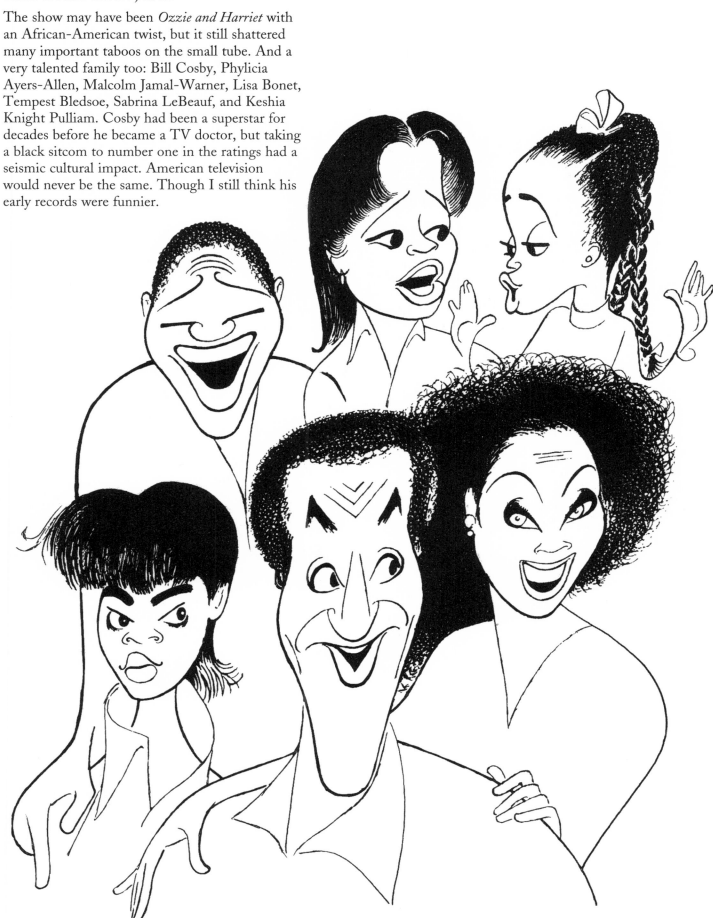

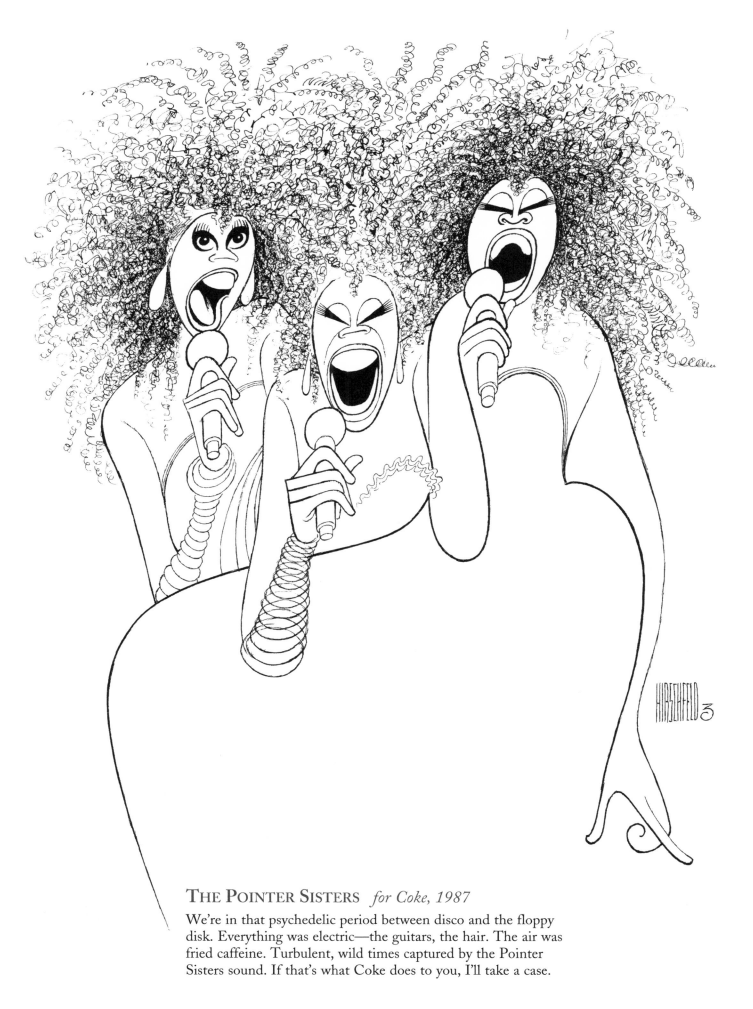

THE POINTER SISTERS *for Coke, 1987*

We're in that psychedelic period between disco and the floppy disk. Everything was electric—the guitars, the hair. The air was fried caffeine. Turbulent, wild times captured by the Pointer Sisters sound. If that's what Coke does to you, I'll take a case.

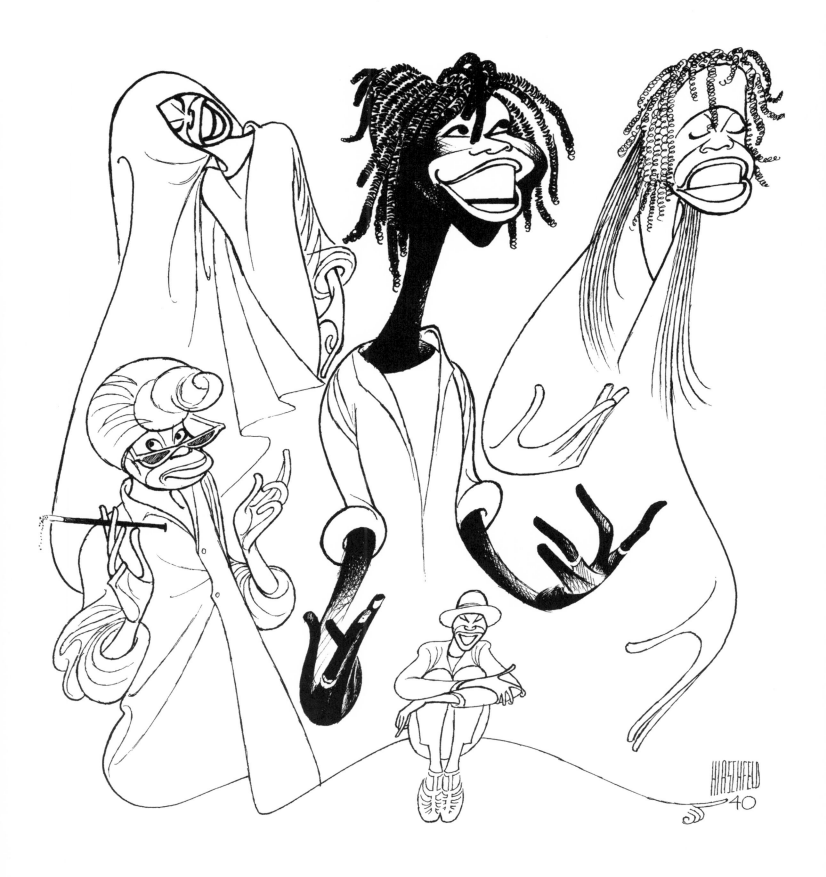

WHOOPI GOLDBERG, 1984

No, there aren't five people on this Broadway stage; there's just Whoopi Goldberg. Just Whoopi Goldberg, who single-handedly made the stage seem more populated than a grand finale at the Met. The show was produced by Mike Nichols and was written by Ms. Goldberg. Whoopi was a relative unknown before this show. That changed. For every one Whoopi on stage I managed to smuggle in eight Ninas. Count them. I dare you.

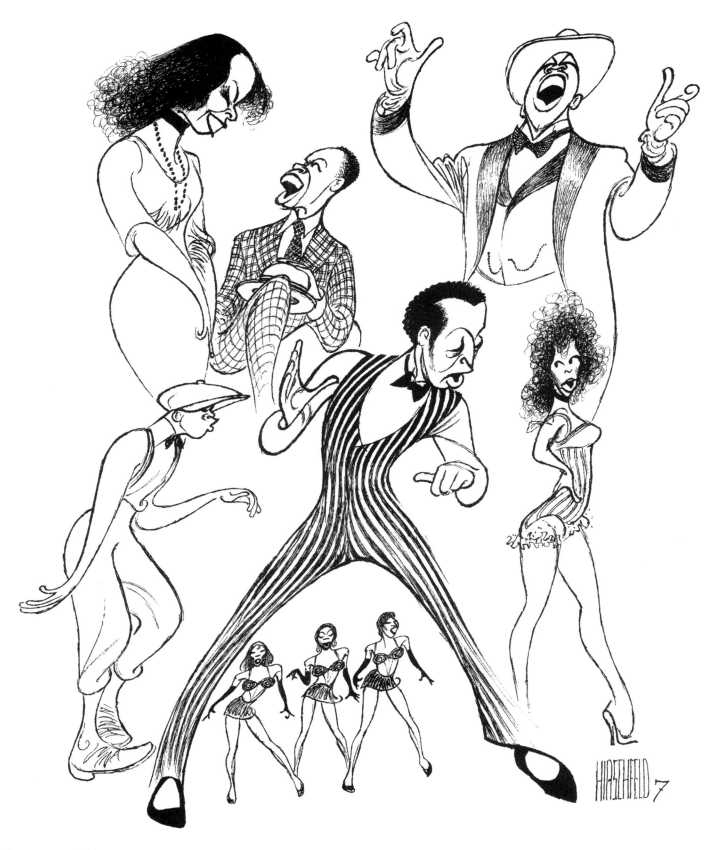

GREGORY HINES *Jelly's Last Jam, 1992*

In drawing black performers I've rarely made their faces black. Very odd when you think about it. I think it's because I feel a person's blackness comes from someplace near the solar plexus. The features, the movement delineate the character while the color ultimately isn't terribly important. Gregory Hines is one of the great ones. And here he touches the lives of everybody in George Wolfe's fascinating production. What a cast! Across the top, they're Tonya Pinkins, Stanley Wayne and Keith David. The bottom row is the unpredictable and marvelous Savion Glover, Allison Williams, Stephanie Pope, Mamie Duncan Gibbs, and Brenda Braxton.

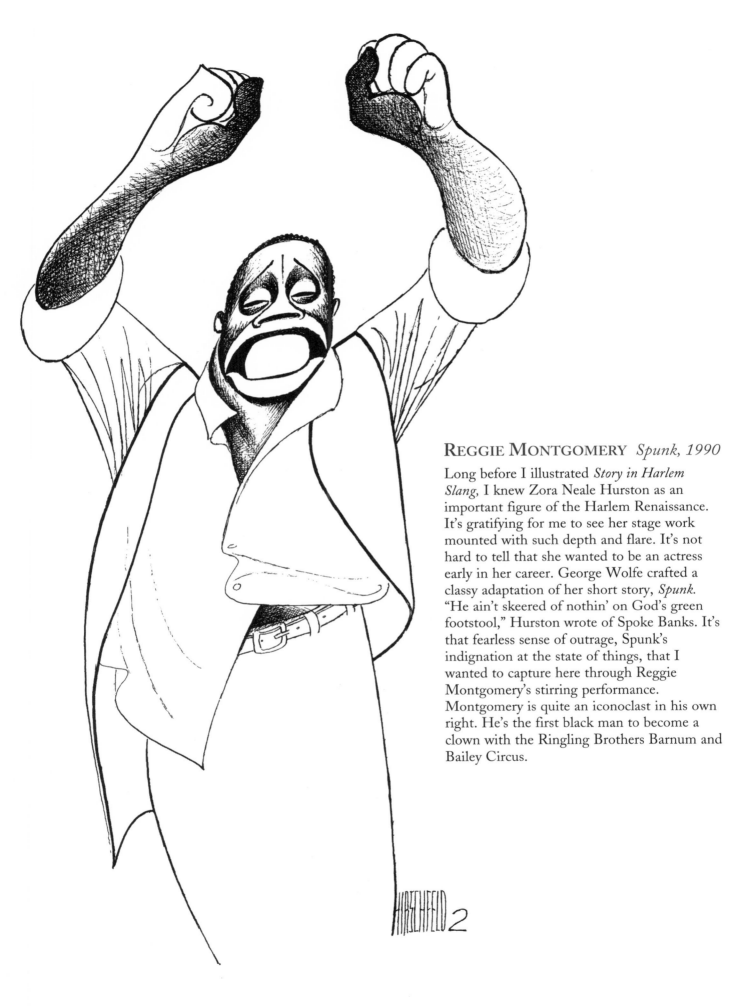

REGGIE MONTGOMERY *Spunk, 1990*

Long before I illustrated *Story in Harlem Slang,* I knew Zora Neale Hurston as an important figure of the Harlem Renaissance. It's gratifying for me to see her stage work mounted with such depth and flare. It's not hard to tell that she wanted to be an actress early in her career. George Wolfe crafted a classy adaptation of her short story, *Spunk.* "He ain't skeered of nothin' on God's green footstool," Hurston wrote of Spoke Banks. It's that fearless sense of outrage, Spunk's indignation at the state of things, that I wanted to capture here through Reggie Montgomery's stirring performance. Montgomery is quite an iconoclast in his own right. He's the first black man to become a clown with the Ringling Brothers Barnum and Bailey Circus.

NATHAN GEORGE *No Place to Be Somebody, 1969*

The Black Power salute came to the forefront in the late Sixties. The country was feeling disconnected from its leaders and many younger black people sought leadership elsewhere. Nowhere was the salute more poignant and filled with righteous warning than in Charles Gordone's Pulitzer Prize-winning play, *No Place to be Somebody.* Gordone referred to the play as his "black black comedy." Nathan George so resonated with the play's sense of intolerable frustration, he won a raft of awards for his performance, including the Obie and Drama Desk awards.

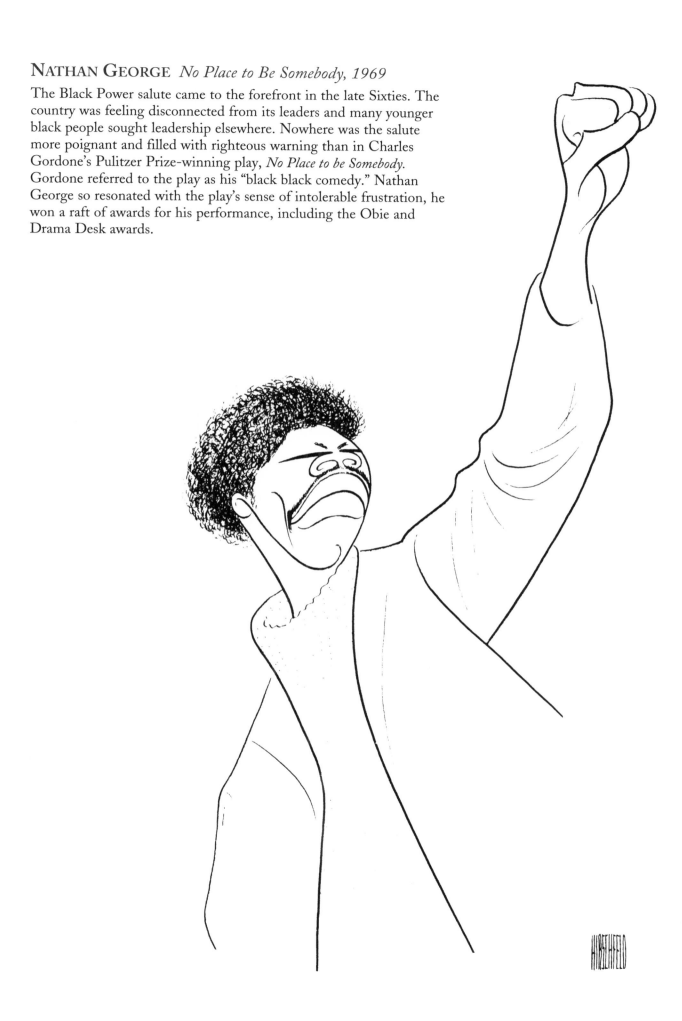

CHARLES S. DUTTON
The Piano Lesson, 1995

August Wilson is about as close as we've come in a long time to another Eugene O'Neill. And Wilson may have discovered his Jason Robards in Charles S. Dutton. Actually the story of Dutton's own life would seem a perfect Wilson plot. He spent years in prison, where he started getting involved in theatre, then came out, got his high school equivalency and eventually landed at Yale, where he met August Wilson. You're right. Too far-fetched.

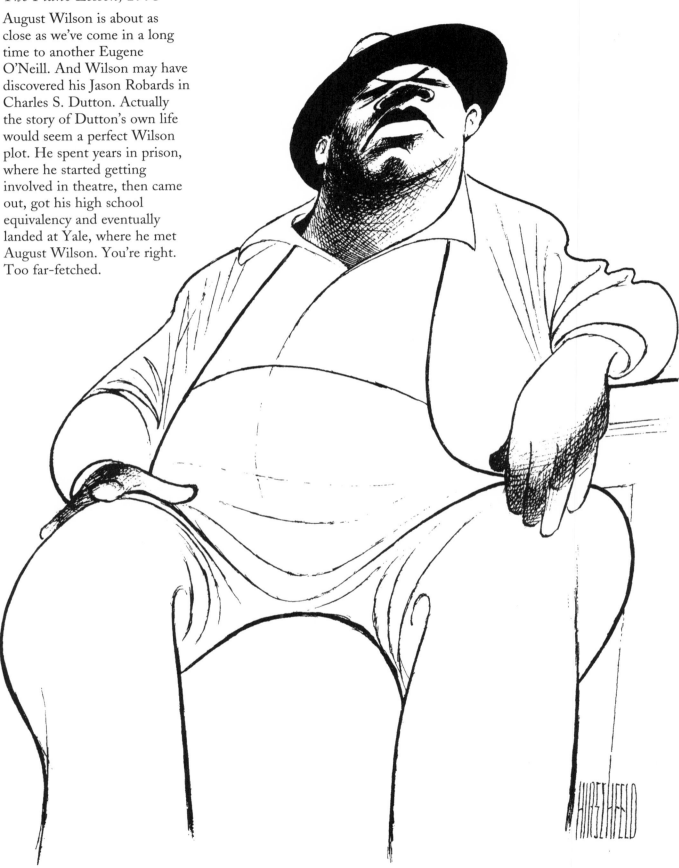

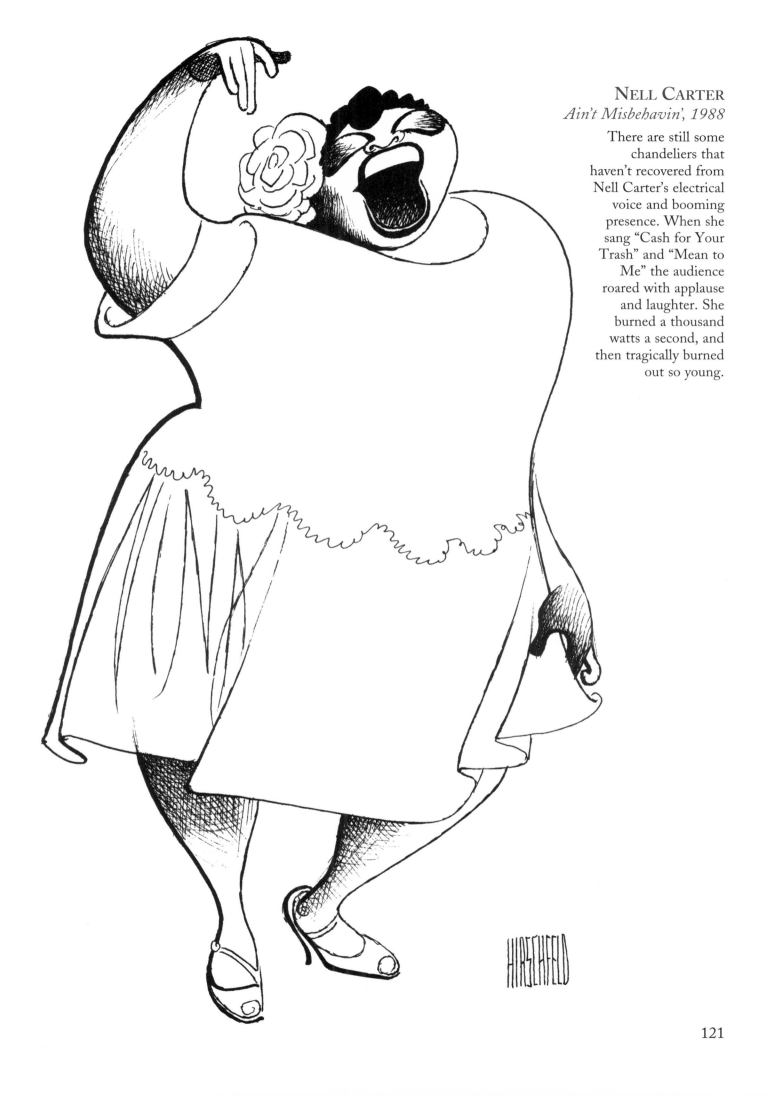

NELL CARTER
Ain't Misbehavin', 1988

There are still some chandeliers that haven't recovered from Nell Carter's electrical voice and booming presence. When she sang "Cash for Your Trash" and "Mean to Me" the audience roared with applause and laughter. She burned a thousand watts a second, and then tragically burned out so young.

HIRSCHFELD

121

FATS WALLER, 1996

Fats Waller grew up right into that period after World War I, learning to hone his piano skills playing accompaniment for silent movies. He started subbing for other cabaret pianists and finally hit his stride as a player in demand for those fabled Harlem rent parties. Never been to a rent party? You don't say! Must be a trust fund baby. Apartments were scarce in Harlem then, for a variety of reasons you can imagine, and rents were sky high when you did manage to land one. One way tenants found to pay the rent was to throw a party just before the first of the month and charge admission. These parties would swing into the early hours and Fats became a star at them.

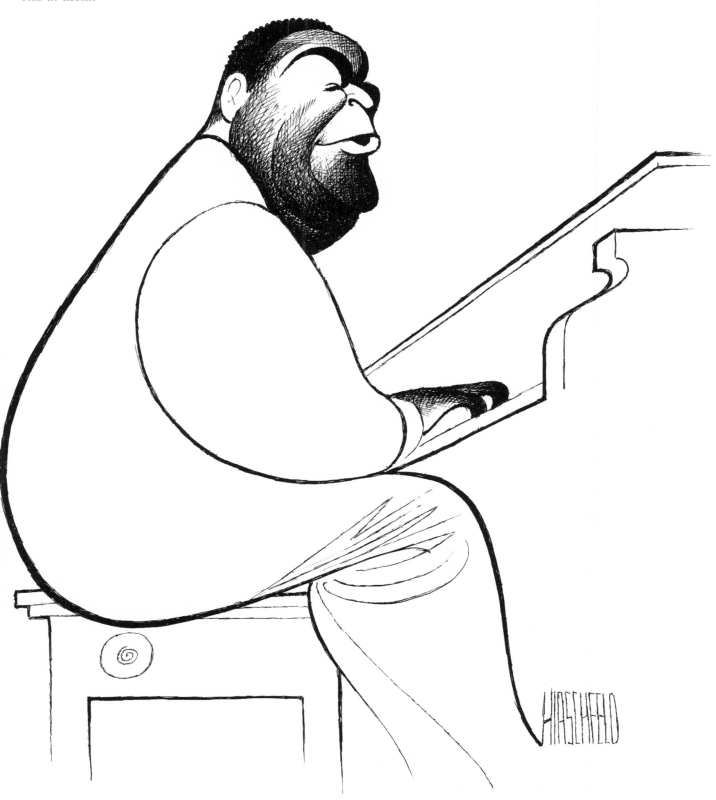

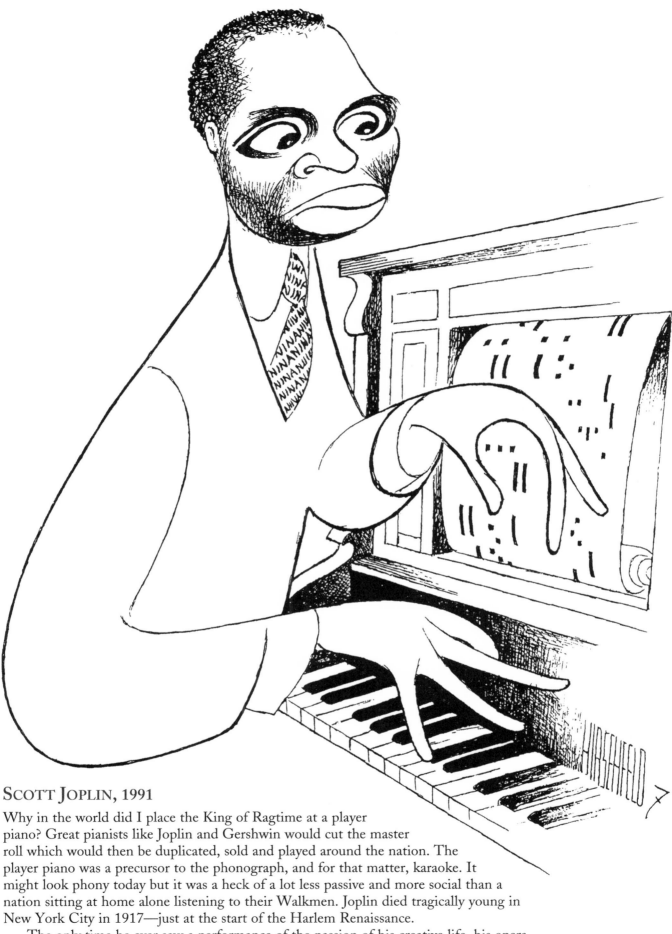

SCOTT JOPLIN, 1991

Why in the world did I place the King of Ragtime at a player piano? Great pianists like Joplin and Gershwin would cut the master roll which would then be duplicated, sold and played around the nation. The player piano was a precursor to the phonograph, and for that matter, karaoke. It might look phony today but it was a heck of a lot less passive and more social than a nation sitting at home alone listening to their Walkmen. Joplin died tragically young in New York City in 1917—just at the start of the Harlem Renaissance.

The only time he ever saw a performance of the passion of his creative life, his opera *Treemoshina*, about a mythical black leader, it was without costumes or an orchestra, before a small Harlem audience. History has proved that Joplin himself was that very real black hero.

LOUIS ARMSTRONG, 1996

If anyone in history ever deserved to blow his own horn it was
Louis Armstrong. Pops, Satchmo, Ambassador of Jazz to the
World. Here he is with his trademark handkerchief blowing
up his usual storm. What never ceases to amaze you about
Armstrong is that he changed not only the way musicians play
music (remember: he all but invented the jazz solo), but the
way singers sing (he's the man who invented scat singing). At
the height of his fame in the Sixties, he lived in a house in
Corona, Queens, not much bigger than and probably not too
far from Archie Bunker's place. But he was galaxies away
from that toxic bigotry. White society wouldn't "let" him,
or any successful black man of the time, live in a
manner befitting his means. No matter. In time,
Pops blew them all—and all their prejudices—away
with his Gabriel's horn.

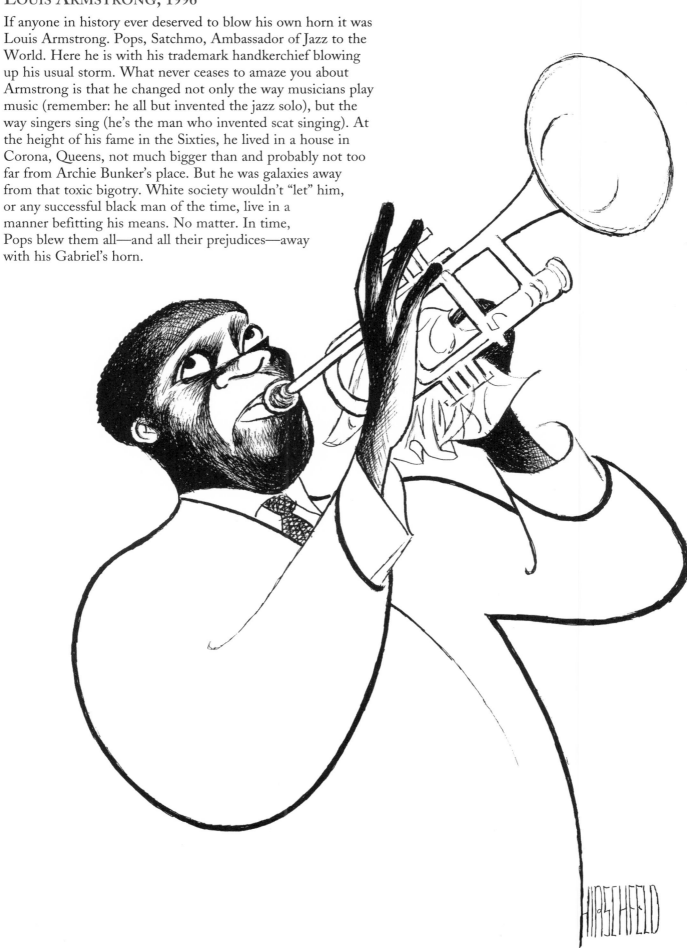

WYNTON MARSALIS, 2002

Whenever I see Wynton Marsalis I think of Louis Armstrong. It's probably because they both came out of New Orleans like a couple of comets. I'm not saying they have twin personalities. But Wynton is having the same incredible impact on jazz that Louis had half a century earlier. There are important musical differences: Wynton is a wonderful classical musician. On the other hand you can't imagine Wynton belting out, "Hello, Dolly!"

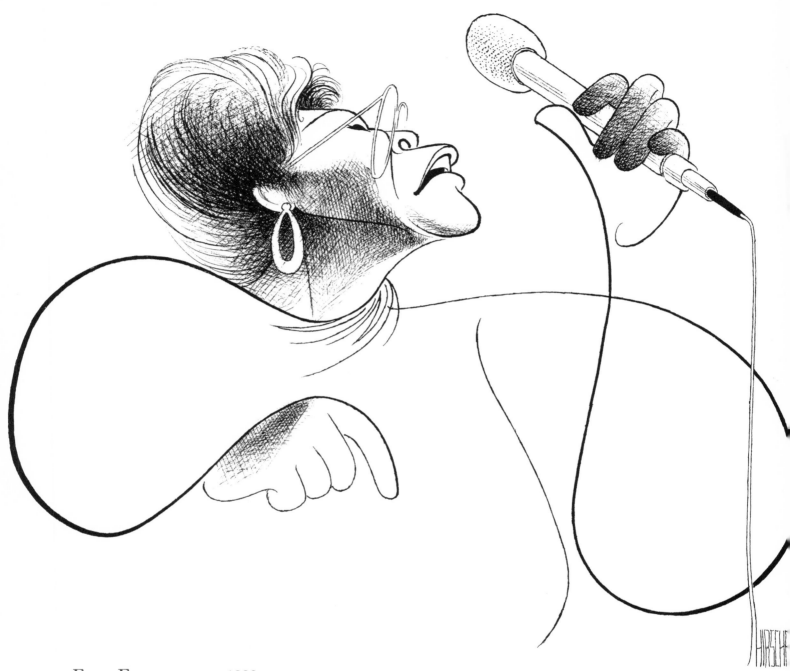

ELLA FITZGERALD, 1993

I've followed Ella since the night Paula Lawrence and I caught her very first appearance at the Apollo Theatre in the Thirties. We were bedazzled by the phenomenal Miss Ella on 125th Street. The Apollo was where you went if you wanted to see talent on the cusp. It wasn't canned ham they were serving. You got every act fresh off the bone. Ella told me she'd won an amateur singing contest in Harlem sometime before. I never know what to do with the darn microphone cord. It's like a thread hanging from your jacket.

Index

Moses Gunn

The
Speakeasies
of 1932

AL HIRSCHFELD
Text by GORDON KAHN & AL HIRSCHFELD
Introduction by PETE HAMILL

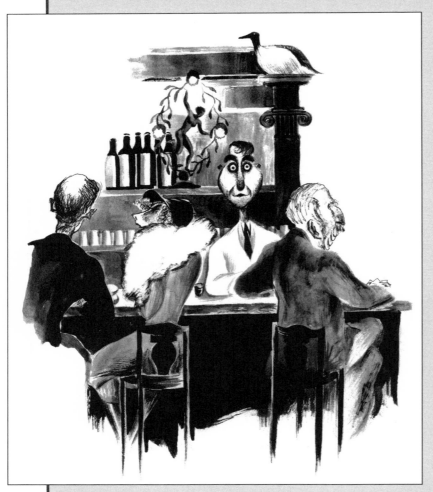

"A pithy, affectionate guide to speakeasies and their denizens from Harlem to the Village. This lavish reprint offers a spirited look back."
—NEW YORK MAGAZINE

"Great news for admirers of Al Hirschfeld: The Speakeasies of 1932 is loaded with great Hirschfeld drawings, irreverent memories and intriguing cocktail recipes . . . "
—THE HOLLYWOOD REPORTER

"Before Nina, the names Harry, Johnny, Mannie, Carlos and Jack filled Al Hirschfeld's delightful vignettes and caricatures, collected in The Speakeasies of 1932."
—THE NEW YORK TIMES BOOK REVIEW

"A charming work of cultural history and a portrait of the artist as a hard-drinking young man." —LIBRARY JOURNAL

"Hirschfeld's art captures something transitory and makes it eternally vibrant and fresh."
—NEW YORK DAILY NEWS

"The large coffee table book is a reminder of how much of the New York City of the last century Hirschfeld knew firsthand."
—PLAYBILL

9 x 12, 96 pages
$32.95 cloth
ISBN: 1-55783-518-7

GLENN YOUNG
BOOKS
www.applausebooks.com